KNITTING
FOR YOUR HOME

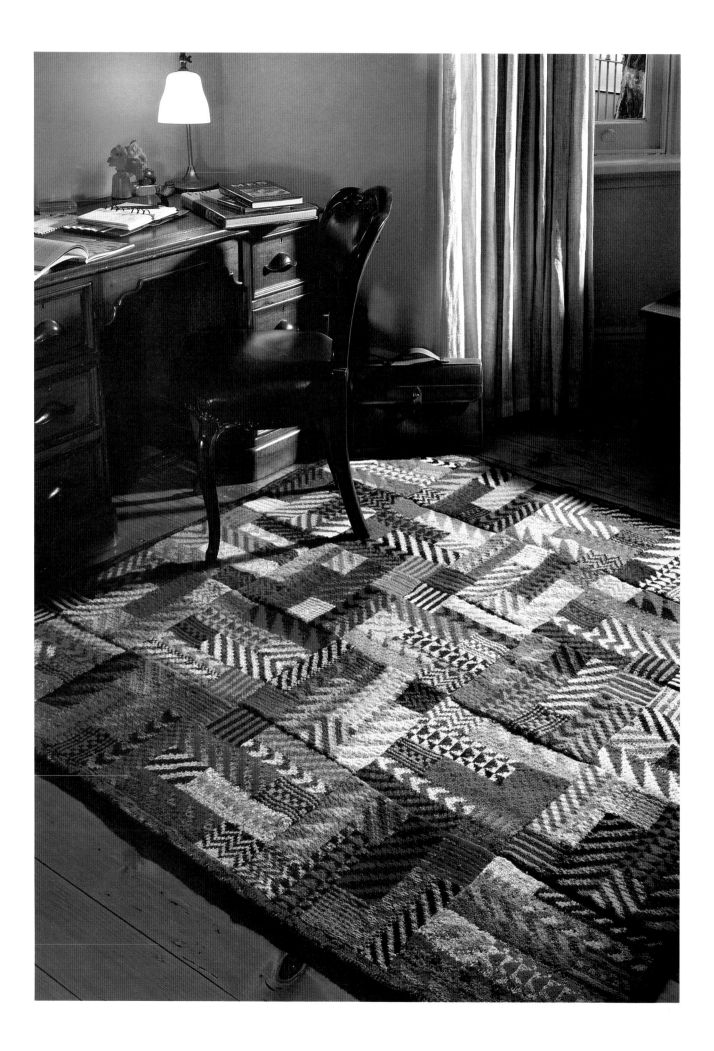

Liz Gemmell

KNITTING
FOR YOUR HOME
Thirty-two exciting projects

Random House
AUSTRALIA

ABBREVIATIONS

K.	knit
P.	purl
st(s).	stitch(es)
st.st.	stocking stitch
beg.	beginning
inc.	increase
dec.	decrease
tog.	together
rep.	repeat
sl.1	slip one stitch
p.s.s.o.	pass slip stitch over

CONVERSION TABLES (U.K. AND U.S.A.)

Terminology

AUST/U.K.	U.S.
cast off	bind off
stocking stitch	stockinette stitch
Swiss darning	duplicate stitch
tension	gauge

Approximate yarn equivalents

You should always check the tension of substitute yarns before buying enough for the whole item.

AUST.	U.K.	U.S.
4 ply	4 ply	sport
8 ply	double knitting	knitting worsted
12 ply or triple knit	Aran-weight chunky	fisherman bulky

Metric conversion tables

LENGTH (to the nearest ¼ in)

cm	in	cm	in
1	½	55	21¾
2	¾	60	23½
3	1¼	65	25½
4	1½	70	27½
5	2	75	29½
6	2½	80	31½
7	2¾	85	33½
8	3	90	35½
9	3½	95	37½
10	4	100	39½
20	8	200	78¾
30	11¾	220	86½
40	15¾	240	94½
50	19¾	300	118

WEIGHT (rounded to the nearest ¼ oz)

g	oz
25	1
50	2
100	3¾
150	5½
200	7¼
250	9
300	10¾
350	12½
400	14¼
450	16
500	17¾
600	21¼
750	26½
1000	35½
2000	70½

Needle sizes

METRIC	U.S.	IMPERIAL
3 mm		11
3.25 mm	3	10
3.75 mm	5	9
4 mm	6	8
4.5 mm	7	7
5 mm	8	6

Random House Australia
an imprint of
Random Century Australia Pty Ltd
20 Alfred Street, Milsons Point NSW 2061

Sydney Melbourne London
Auckland Johannesburg
and agencies throughout the world

First published by Random Century Australia, 1991
Copyright © Liz Gemmell 1991

National Library of Australia
Cataloguing-in-Publication Data

Gemmell, Liz.
Knitting for your home.

ISBN 0 09 182634 9.

1. Knitting – Patterns. I. Title.

746.432041

Created and produced by David Ell Press Pty Ltd
95 Beattie Street, Balmain NSW 2041

Design and cover concept: Zoe Gent-Murphy
Design layout: Christie & Eckermann Art and Design Studio, Sydney

Typeset by Asset Typesetting Pty Ltd, Sydney
Printed in Hong Kong through Colorcraft Ltd.

Acknowledgements

My thanks to the people at David Ell Press for their enthusiasm and friendliness.

For her skill in organising and inspiring me, thank you Celia Pollock.

For typing the manuscript, thank you Margaret Keys.

For the photographs, thank you André Martin; and to Leigh, my husband for the extra photography, thank you.

To the friends who lent their homes as settings, thank you Kathryn Lamberton, Carolyne and Ferg Fricke, Liz and Keith Post and Norma Ahern.

Finally to the knitters who helped me realise my project, an especial thanks to Olive Threlfall, Liz Post, Jean Perryman, Denise Gemmell, Margaret Bell and Caroline San Miguel.

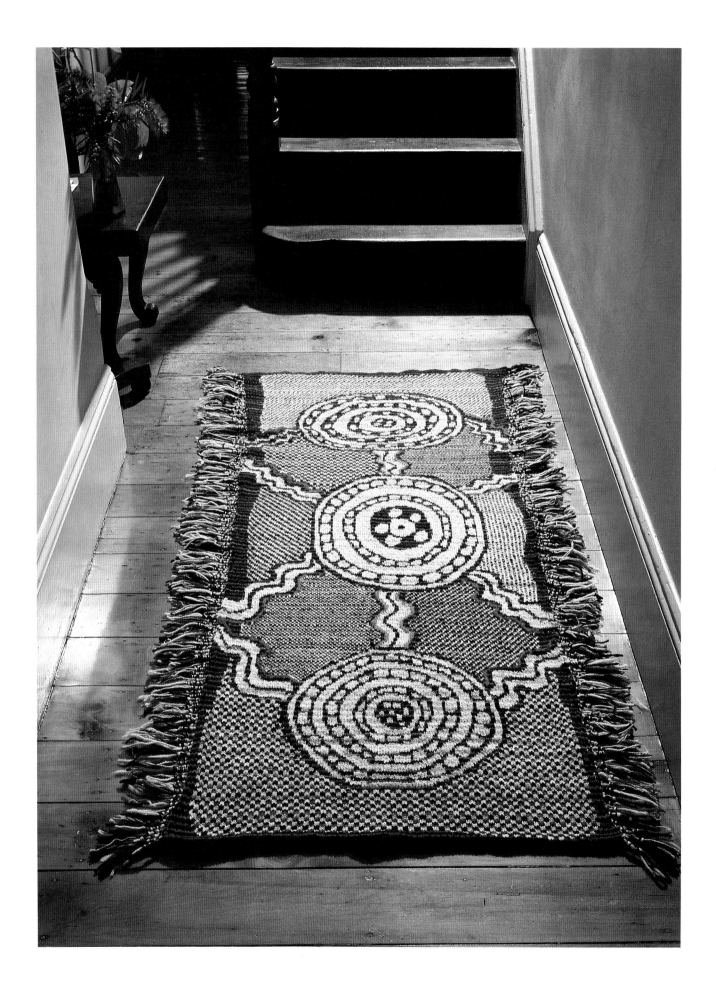

Contents

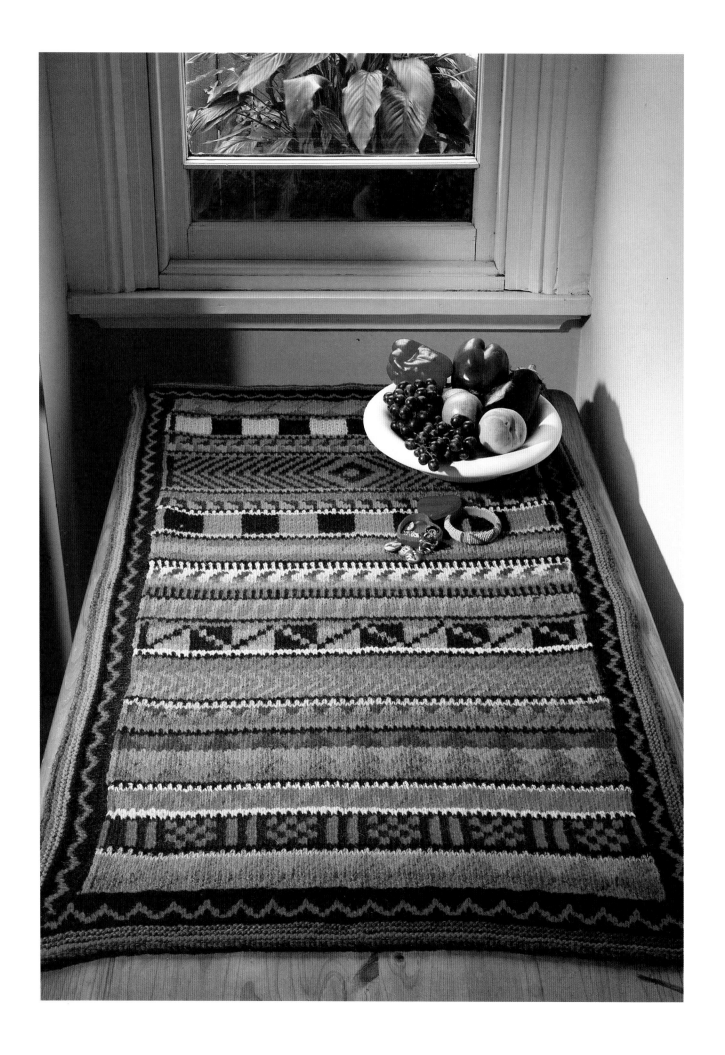

Introduction

'Why not knit a rug?' I thought. 'It wouldn't be hard,' I reasoned. 'It may even be fun,' I told myself. It certainly wasn't a new concept, but it would be a new challenge for me. My first attempt proved successful. That was the small *Harlequin* rug. The second venture was the two metres square *Persian Star.* I was happy. The rugs were floor pieces. Their weight was akin to a heavy Kilim. They could not be as solid as a woven and knotted rug, but they certainly had all the suitable attributes of a floor piece.

The beauty of knitting a rug is that most knitters already have the basic skills and all of the equipment. It struck me as I wrote out the instructions that all that was needed to make a two or three metre rug were the knitting needles, yarn, and time. The process was simply to cast on the stitches, knit the rug and cast off. No need to build frames or buy canvases and other implements.

That makes the process sound very simple which, when analysed like that, it is. The techniques I describe are the same as for garment knitting. Some of you may already have these techniques and simply need a few hints on applying them to rug knitting.

But how long does it take? — a most frequently asked question. A small rug, say, *Harlequin* or *Diamond,* takes no longer than it takes to complete one adult sized sweater. If you know you can knit one garment a season then tackle one of the smaller projects, such as a cushion, mat or upholstery piece. If you can knit two garments a season, then you may consider the *Rainbow Runner, Forest Flowers* or *Flashpoint* for example. If you can manage three or more garments a season, then any of these rugs is within your scope.

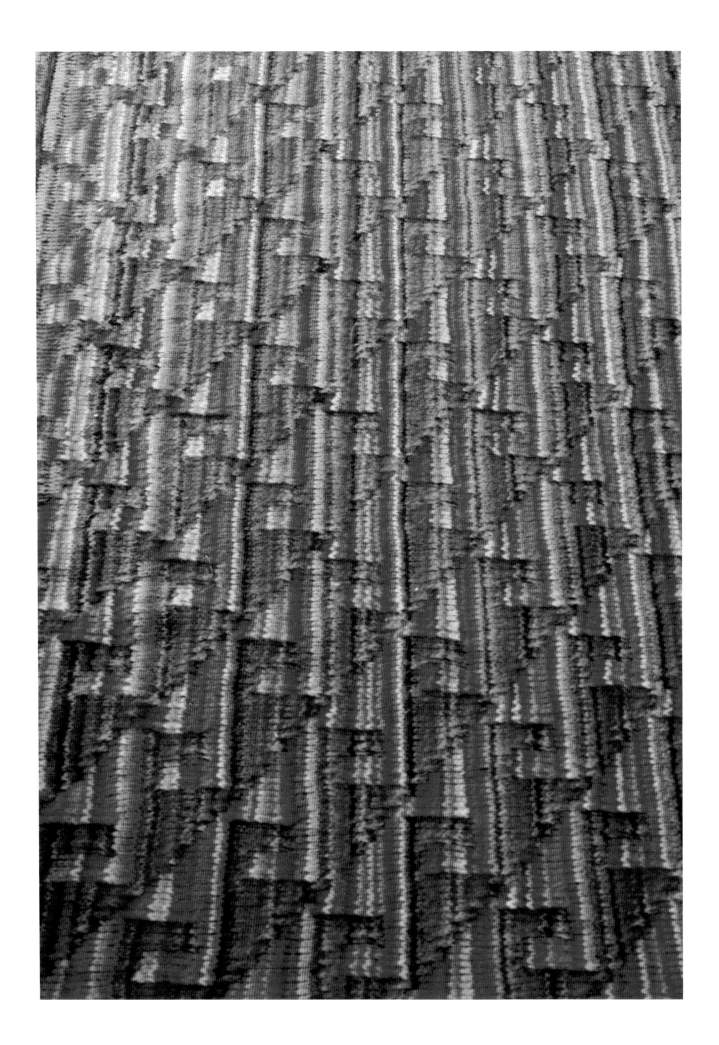

History

Knitted carpets have been known since the 17th century when they were made in the Alsace region bordering France and Germany. To knit a carpet was part of an apprentice's entrance examination to a German knitting guild. Knitting guilds were established in many European countries but only Germany appeared to stipulate that a knitted carpet be part of a knitter's required skill. In his seventh year each apprentice had to demonstrate his skill by producing a beret, a shirt, a pair of stockings with clocks (a textured or coloured pattern) at the ankles, a cap and a carpet — all this in thirteen weeks.

The carpets were probably worked on a knitting frame which was made by fixing a series of wooden nails or hooks, called pegs, on to a board. The peg boards were similar in concept to 'cotton reel knitting' (also known as French knitting or 'knitting Nancy') which is still sometimes done by children. Nails are placed around the hole of a wooden cotton reel to hold the stitches; yarn is then wound over each nail and the stitch is lifted over the yarn to make a new stitch. Unlike this simple system, the peg boards were very sophisticated and variations were devised to deal with different colours and textures, and cylindrical knitting.

The carpets created in those days were very ornate and colourful, sometimes with as many as twenty different colours. The decoration included floral, animal, folk and heraldic motifs, and biblical scenes. Most of them were produced for patrons and were used as wall-hangings and bedspreads, or as rugs or cloths for tables and floors; many of them were as large as two metres square.

Although few examples remain, some can be seen in places such as the Victoria and Albert Museum in London, the Museum of Art in New York, and in Strasbourg (France), Wroclau (Poland) and Colar and Nuremberg (Germany).

In the Victorian era, knitting became principally a domestic craft, though some small rugs were produced, often knitted with a rag or wool pile and combined with crochet and embroidery. This era presented an opportunity for knitting skills to be refined and documented, and the challenge was to produce intricate examples of one's abilities.

During the First World War, knitting skills were concentrated on making garments. The public was called upon to provide socks, jerseys and balaclava helmets for the war effort. Standardisation of printed knitting patterns began as newspapers and women's magazines published more and more new designs. After the Second World War the Red Cross organised school children and youth and church groups to knit squares which were collected and sewn up into 'refugee' blankets and rugs. Assembling multicoloured squares is still a popular way to create rugs, and some variations of this idea are included in this collection.

Since the 1970s we have continued to push back the frontiers of fashion knitting. Exotic garments, evening wear, textures and colours make knitting a much more exciting and creative craft. Contemporary garment knitters have a variety of skills and techniques equally well-suited to rug knitting. To create a rug or other piece for your home can provide a new challenge and it is a perfect medium through which to express your own creativity.

Techniques

First, a clarification of terms. Fair Isle, Shetland, Norwegian, Jacquard and colour stranding are some of the names that apply to two-colour knitting. In this book, I will use Fair Isle to refer to the way of making designs by knitting with two colours across a row.

Fair Isle knitting was used in garments that were knitted in the round, as most garments traditionally were. The technique for handling two colours along knit rounds became quite streamlined, easy to handle, and produced a very even surface to the knitted fabric.

Only knit stitch is needed in the round to produce stocking stitch which means that the knitter only works with right side facing. The designs and motifs can therefore be quite intricate, as awkward counting along purl rows is not necessary.

When I first began knitting Fair Isle, I used only my right hand to work both colours. Thus I would knit with colour A, drop A, pick up B and knit with B. The system worked, my tension was fine, but it caused the strands at the back to cross over.

Incorrect stranding (wrong side of work).

This caused the stitch on the right side to lie crooked. The crooked appearance does not affect the durability of the knitted fabric, just its appearance. It was much later that I learned about parallel stranding and the difference it makes to the smoothness of the fabric.

However, it was from this beginning that the other techniques followed.

Parallel Stranding

To produce parallel stranding, let colour A always be on top of colour B on knit and purl rows. Strand B is then always under strand A. Strands A and B travel along the row in parallel lines and never cross. The technique is manageable using the right hand to control both colours, but using both hands to control one colour each does prove to be easier and faster.

Stranding yarn across wrong side of work.

Parallel stranding makes the stitches lie correctly on the right side and not twist towards the left or right. When working Fair Isle always take both colours to the end of the row and twist both yarns so that they both start together at the beginning of the next row. When knitting garments, the strands must be loose or the work will pucker and the tight stranding will not allow the garment to have the required amount of stretch for easy wear. To eliminate tight stranding, always stretch the stitches just knitted along the right hand needle before stranding across with the next colour.

In the rug designs I tried to keep the stranding distance to a minimum number of stitches.

Two-Handed Stranding

Hold colour A in the right hand and B in the left hand. Have yarns over each index finger with the last two fingers of each hand controlling the tension.

Knit with the right hand the required stitches then hold back A. Now knit with colour B in the continental style. That is, make B stitches by inserting right hand needle into the stitch, looping B around needle and bringing it out.

With the right hand pull back stitches just made on right hand needle before commencing each lot of A or B stitches so that the stranding does not become tight.

This method automatically puts A strands on top of B strands thus forming parallel stranding. It also stops any twisting of the two yarns.

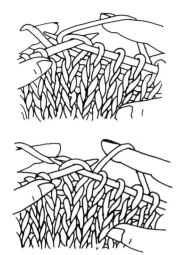

Two-handed stranding on knit stitch.

The same procedure applies for purl rows. Purl A with right hand, holding B in the left hand. Stretch stitches across right hand needle before commencing to purl with the B colour held in left hand. Insert the right hand needle into stitch purlwise. Bring the right hand needle around so yarn B is wound around and pull the loop through.

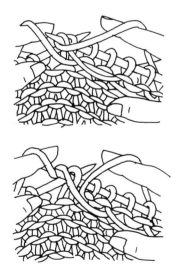

Two-handed stranding on purl stitch.

In general, stranding the two-handed way works very well with small repeat motifs. When five or more stitches are worked then the strand must be woven in at least once to reduce its length. A long strand catches very easily and pulls the fabric.

This type of stranding was used in the rugs *South Seas* and *Flashpoint* and for the various fill-in patterns of *Terra Australis*. The solid colour sections were worked as woven Fair Isle.

Woven Fair Isle

Woven Fair Isle opens up knitting to large, free designs. I remember having great difficulties knitting certain large designs — do I use picture knitting here or do I strand or weave? Woven Fair Isle reduced most of the dilemma. By combining woven Fair Isle with intarsio (picture knitting), a whole new world of colour design opens up for you.

My information came piecemeal, painfully slowly. No doubt, there is still more to be discovered, but I feel I now have several techniques at my fingertips to do my bidding and I do not have to be limited in design and knitting because of lack of these skills.

These techniques are the ones I wish to present to you — all in one book and not in piecemeal sections as I experienced. They are not the ultimate in techniques, but they do give knitters 'wings', as it were, to soar to greater heights of expression.

A lot of the pieces in this book use the woven technique. This knits up into a very firm texture, has minimal stretch and has no loops at all on the wrong side. Indeed, the wrong side has a very attractive look especially when geometric patterns are worked. Woven Fair Isle also allows intricate and large two-colour designs to be worked easily.

By weaving in each stitch, you actually raise or lower each stitch on the right side thus creating a surface texture and giving the knitted rug a unique appearance. The raising and lowering of stitches is more obvious

Wrong side of Banksia rug, during working, which shows woven strands, fringed edge and contrasting threads.

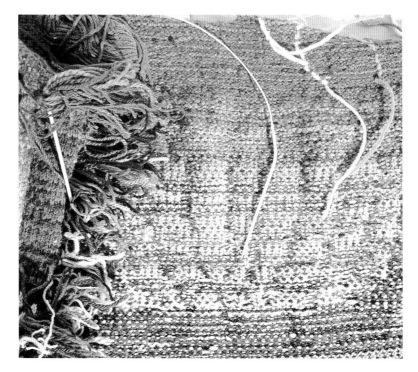

Woven Fair Isle allows for greater scope in designing and adapts easily to rectangular or circular shapes.

A repeat pattern with a large number of stitches is easily accommodated by woven Fair Isle.

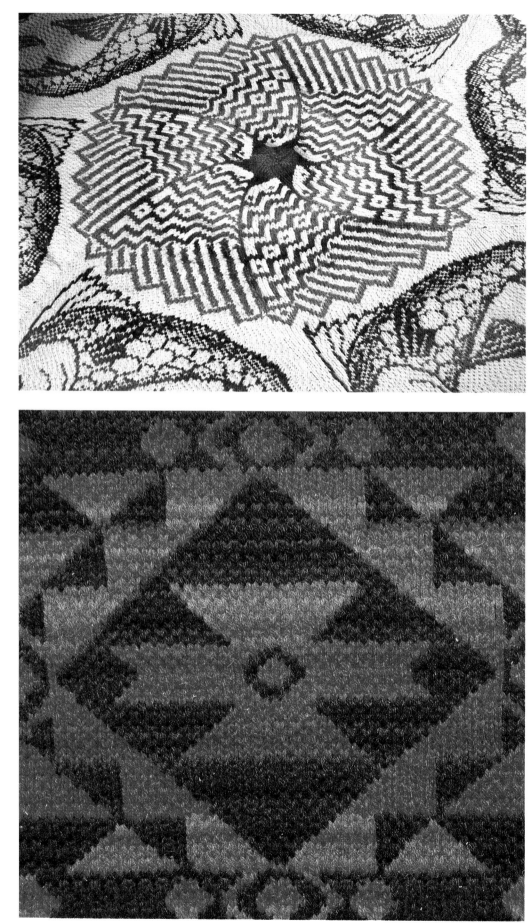

when small needles are used. When working woven Fair Isle on garments with the recommended needle size, this texture is not as apparent. Also the softer garment tension allows the second colour to show through on to the right side. This is apparent in *Skazka* which was knitted in garment wool and regular needle size. I find the second colour showing through gives an added dimension to the design. Using small needles as for the rugs, does not allow the colour to show through.

THE METHOD

Weaving in colour B

Hold colour A in the right hand and colour B in the left hand. Knit with A and each time the right hand needle is inserted into the stitch, the B strand is alternately knitted with the A colour or left out. Say 10 stitches need to be worked in A, then the first A stitch knits in the B strand, the second stitch does not, third stitch knits in the B strand, fourth stitch does not and so on. By lifting your left index finger and thus raising or lowering the B strand you can easily control the B strand being woven in. When your left index finger raises the B strand, it can be placed over the left hand needle for easier weaving in.

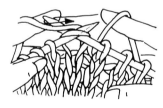

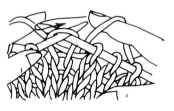

Two-handed method on knit stitch, weaving in left-hand yarn.

When I first learned this method, I would change the colours over from hand to hand when I had to knit with B and weave in A. For large numbers of stitches I still use this method. However, for small numbers of stitches, changing colours over proved to be a nuisance. I was then shown the method for weaving in A while still holding it in the right hand.

Weaving in A

Insert right hand needle into stitch, wrap A around needle as if to make a stitch but do not knit it. Wrap B around the same needle. Bring A back around and pull B through to make the B stitch. Next stitch and each alternate stitch, B is worked in the continental way (i.e. yarn is held in the left hand). The third and each odd numbered stitch is worked as first described — insert needle, wrap A around needle, then wrap B around needle, unwrap A and bring B stitch through.

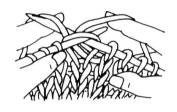

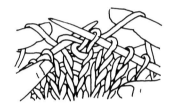

Two-handed method on knit stitch, weaving in right-hand yarn.

It is cumbersome to describe and slow at first to knit, but with a little bit of practice it becomes fast and fluent. As most of the Fair Isle rugs are knitted in knit rows only, you will certainly gain the experience. And again, it's invaluable when knitting garments.

Picture knitting

Six of the rugs are worked in this method, also called intarsio.

The method is very simple. It can only be worked on flat pieces, not in the round, in rows that are turned and worked back. Separate balls or bobbins of each section of colour are used. No colour is stranded across the back to another colour section.

Where the two colours meet is called the colour change. Yarns must be twisted around each other at the colour change to prevent holes from forming.

On knit rows at the colour change, take the old colour and put it over to the left and bring the new colour up. Give a gentle tug to the new colour to pull up excessive looseness and continue knitting with it. This forms a small vertical loop. Allow the old colour to hang until needed again.

7

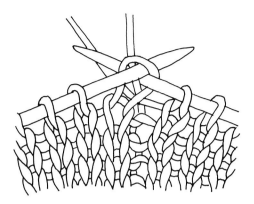

Colour change along knit row.

On purl rows, take the old colour over to the left and pick up the new colour. Give a gentle tug with the new colour and purl as needed.

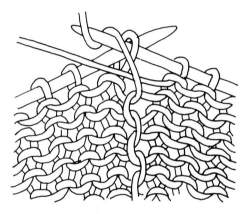

Colour change along purl row.

The loop at the back can be carried over 2 to 4 stitches if needed. Make sure loop is not tight. If preferred the loop may be woven in once to reduce its length.

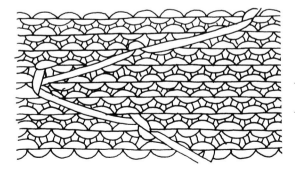

Yarn carried across back of work.

When working garter stitch, all knit rows, on each even numbered row, bring the worked colour to the front of the work at the colour change, twist both yarns. Take new colour to the back of work and continue knitting as needed.

Odd numbered rows are treated as normal knit rows in picture knitting. The colour change will be very neat and being in garter stitch, your piece is reversible.

STRIPS

At first I tried working a large number of stitches using double yarn and it proved difficult. The firmness of the knitted fabric was fine, so my solution was to knit the floor piece in narrow strips. These were easy to handle, still allowed for versatility of design and proved to be a boon to knit in warm weather.

To keep the edges even and firm, slip the first stitch of every row, knit or purl. This forms an edge stitch which is easy to identify when sewing the strips together.

Do not slip the first stitch if that stitch is in the first row of a new colour. The old colour from the row below will be brought up otherwise.

KNOTS

When joining in new colours, tie a reef knot and do not weave in the tails as you knit as it will show up as uneven fabric on the right side. Weave the tails with a crochet hook when the rug is complete. Weave in through the colour change loops at the back. Keep additional yarn knots to the edges.

Combining Woven Fair Isle and Picture Knitting

Sections of Fair Isle may be joined by using picture knitting. An example of this is the patchwork rug. Each patch has two Fair Isle sections side by side. Twist the two colours of one section with the two colours of the second section. A neat join will result.

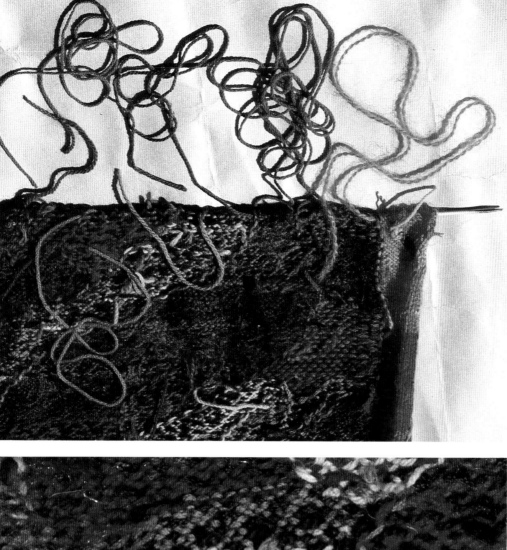

Wrong side of Waratah showing short lengths of colours. The short lengths are twisted around each other, while the background colour is simply worked across the row.

Wrong side of Clouds of Colour after loose threads have been woven in.

Overleaf: Banksia in progress.

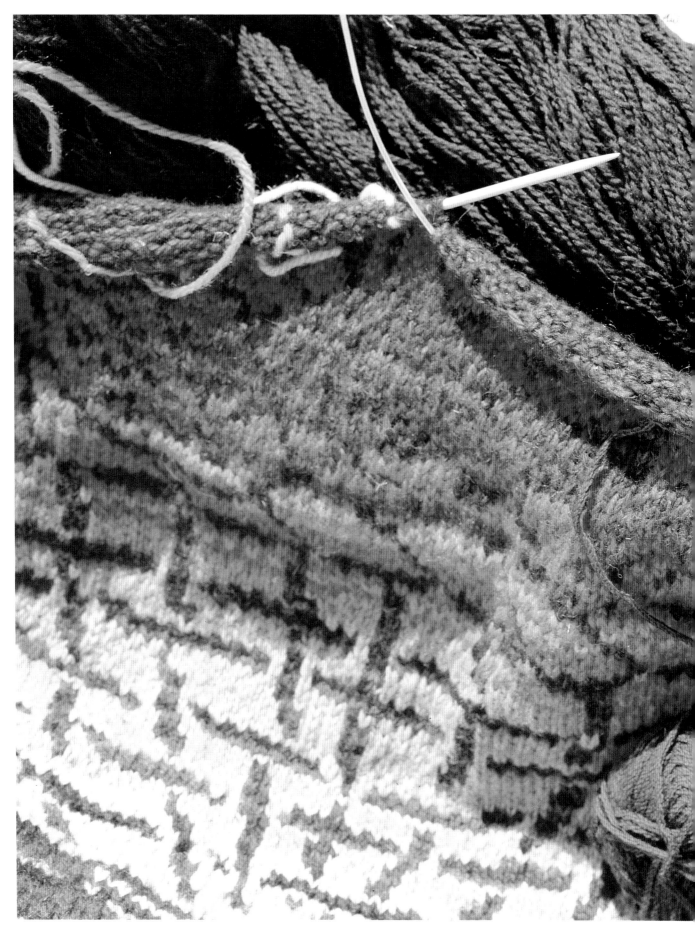

Tangles

When working an intricate intarsio piece or a garment with a lot of balls or bobbins, tangles are inevitable. My solution is to select one different colour each row or so and untangle it. Trying to untangle all the balls is time consuming and does not make your work any better. Untangling one ball at a time keeps the tangle manageable.

When working *Clouds of Colour* and *Waratah* tangles are avoided as each colour — except the woven-in outline colour — is a short length which can be cleared by pulling out.

Knots

REEF KNOT

There is no hard and fast rule about using or not using knots to join yarns. I don't hesitate to use a reef knot with tails 5-8 cm long for either woven Fair Isle rugs or garments. For one colour garments, the knots are kept to the sides.

Hold yarn in each hand, place right over left and twist yarn under, then place left over right and twist under. Pull both tails to tighten.

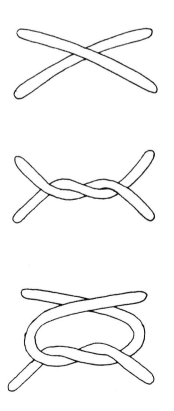

A reef knot may be loosened and adjusted so as to be completely invisible on the right side and only the tails showing on the wrong side. Pull one tail firmly and the other thread forms a double loop which will slip along the pulled thread to the required position. Pull both tails and the knot reforms.

As the tails lie in opposite directions it is best, where possible, to weave the tails in the direction they lie as you knit.

To create the colours for the patchwork rug, I made up large balls of each colour group. For example, the blue ball had a variety of blues ranging from aqua to royal blue and a variety of yarns and combinations of plies, all joined with reef knots. The knot position was easy to adjust as it came up to be knitted.

OVERHAND KNOT — FRINGES

The fringe at the sides is an intrinsic part of the rug's structure. Here an overhand knot is tied at the edges. When pulled tightly the knot is quite difficult to undo and the tightness reduces the bulk of the knot. The knot is still too bulky to use when knitting garments, even at the sides, so avoid this knot for garments.

For rugs with fringes, begin the row by leaving the 12-20 cm tail of the two yarns. The first row will have the tails loose at both ends. At the beginning of the second row, have the two new yarns match the first ones in length and tie an overhand knot as close as possible to the stitches. At the end of the row, match the length with the previous tails and cut. I don't tie a knot yet. I found the left hand side of my work was often longer than the right hand side. By waiting until three rows were worked and then tying the overhand knot with the last two rows of tails, I could keep both sides even. Push the end of the row back onto the thin wire section of the circular needle. Pull gently the last two rows of tails (four threads usually) to tighten

up the stitches at the end of the last two rows. Do not pull so tightly that the work puckers. Now tie the overhand knot loosely and slip it down as close as possible to the end of the rows.

Added interest can be given to the side fringes by adding extra overhand knots or even working some macrame.

When blocking a fringed rug, ensure all the fringe is straight by combing with fingers. Trim fringe when rug is dry.

Finger Stalls

To aid working with thick yarns, small needles and a large number of stitches, finger stalls or thimbles for one or two index fingers are recommended. The stalls are made from scraps of soft leather of medium thickness. A correct scale pattern is given below. Stitch together as shown either by hand or longest stitch on the sewing machine. Use stall on index finger(s) to push the point of the needle when knitting. I found the stalls useful and some knitters commented that they found them useful for garment knitting as well.

Centre

Fold in half and stitch along edge.

Actual scale finger stall.

Tension

This is one occasion in knitting when tension is not critical, with the exception of the two circular rugs which have a section to themselves.

The general criterion for tension for the rugs is to produce a firm fabric. To do this, smaller needles than for garment knitting are used. How small a needle depends on the knitter and the available yarn.

For most rugs I have used rug yarn, a woollen thread of about 14 ply. When certain colours were not available, I substituted with garment wools, for example two strands of 8 ply or a 12 ply with an 8 ply or other various combinations. The woven Fair Isle rugs using this variety of yarns were worked on 4 mm needles. If you find these needles difficult to handle, you can increase the size of the needle or, indeed, you can even go down a size. I used 3.00 mm needles for two mats and an upholstery piece. The smaller needles gave a crisp texture and the look of embroidery to the stitches.

Picture knitted rugs were worked with double yarn and 4.5 mm needles. Again you may alter the needle size for your knitting comfort.

In both styles of knitting, a finger stall can be invaluable when dealing with small needles and thick yarn.

You may notice that the rugs have been worked to a range of tensions. Even though I've used basically the same sort of rug and garment yarns and the same needles, the tensions vary a little. This range of tensions is caused by the quantity of rug yarn to garment yarn which is different for every rug.

TENSION, NEEDLE AND RUG SIZES

To determine which needle suits you and the yarn best, work a sample in the technique of your selected rug. Cast on 50 stitches and work 50 rows in your available yarns with various needle sizes including the size stated in the instructions. Select the sample that produces a firm fabric and with the needles that you find most comfortable to knit with.

Compare your tension with the tension given in the instructions. If you have fewer stitches to the 10 cm than stated, then your rug will be wider than the dimensions given. If you have more stitches, then your rug will be narrower than the dimensions given.

If your rug does work out to have different dimensions from the given rug, this may still suit your needs. In this case, there are no adjustments to be made. Follow the instructions as written. However, if your rug needs to be a specific size then you need to adjust the number of stitches and rows. Study the graph and instructions and with a few sketches and diagrams and some simple calculating, you will achieve your specific dimensions.

Most of the graphs are such as to allow for as many repeats of the pattern as you desire. Remember that motifs can be halved both in stitches and in rows to accommodate your size. Borders on all four sides may be made larger or smaller as necessary.

Errors

So easy to make and often so hard to correct! But there are a few hints to get over this universal failing.

When the counting of the stitches on the graph does not tally with the stitches on your needle, stop and check immediately. Check for dropped stitches or the obvious miscounting of stitches.

Stop your work and leave it when errors are occurring too frequently. I found a break most useful as it helped me to return to the work and make fewer errors. In particular a new graph, or tiredness, would cause errors and this became quite frustrating, but soon the working time increased between the breaks.

If you find an error several rows down, knitting stitch embroidery in the correct colour can be worked over it.

Sometimes the error may have occurred at the beginning of a row and you may have already knitted over a hundred stitches. In these cases, if your counting is only one stitch out, either knit two stitches together or make one stitch. In the next row, you will need to compensate for this type of correction by either increasing or decreasing a stitch. This method is a desperate measure and certainly not recommended for garments or simple colour designs, but working on a complicated woven Fair Isle design this type of adjustment and correction is hard to detect.

Graphs

The graphs may appear to be rather intimidating but there are a few simple procedures to make the graph user friendly.

First, get an enlarged copy of the graph. Now it's easier to read and handle, and to mark.

Colour in the graph and the design becomes clearer. Use pencils so that the grid is still visible.

Mark off the rows as you work them. Use a soft lead pencil that erases easily, especially if you are working on a repeat motif.

On a large graph such as *Banksia*, fold away the worked graph every 5 to 10 rows.

This helps you find your place more quickly and gives you an instant appreciation of your progress.

Some graphs become very easy to work, graphs such as *Harlequin, Persian Star* and *Flashpoint.* I combined the knitting with my favourite viewing or listening programmes. Other graphs such as *Banksia* and *Waratah* need to be read like a book, so do arrange for a comfortable position for yourself to knit and read the graph, and to have access to the colours.

When working knit rows only to form a fringe, always read the graph from right to left. On completion of knit rows, cut the yarns and start again with new yarns at the beginning of the row.

Alternative Uses of Graphs

You may wish to use some of the graphs or motifs for garments, shawls, etc. These would be knitted in garment yarns and to a garment tension. Possibly the stitch would remain similar to the rug tensions, but the row tensions would be appreciably different.

Knit up a sample first in your chosen yarn and recommended tension to see if any adverse distortion occurs. More often than not, the graph as given will still be suitable. If distortion does occur, what will happen is that the sample will show the graph as too wide in proportion to the height of the design. In this case the graph would need to be redrawn, adding extra rows to give the motif a better proportion. This is more likely to be necessary in floral designs and the fish motif rather than in the geometric designs.

Yarns

Rug yarns are most suitable for these works. Rug yarn is slightly thicker than a 12 ply garment yarn and is spun to have less elasticity. Rug yarns may be pure wool or blended with synthetics. I have included the names and addresses of rug yarn suppliers at the back of the book.

When certain colours in rug yarns were not available, garment wool was substituted. Generally, I used a 12 ply and 8 ply combination, sometimes even 5 or 4 ply yarns were combined because of their colour suitability. Pure wool or wool blends are preferred and yarns that have a smooth or crepe spin rather than a fluffy or brushed finish.

Pure wool yarns have so many advantages — insulation, durability, fire resistance and shape holding that you risk ruining your hand work with lesser quality yarn.

For working the floor pieces in picture knitting, keep all the yarns identical in ply. Obvious discrepancies in plys produce sections of work of different size to the adjacent sections as their tensions do not match. This becomes awkward when sewing up the floor pieces.

Yarns may still be mixed, such as using a garment yarn with a rug yarn, or using two 12 plies or two 8 plies or any combination of yarns, but the whole rug must be in that same combination.

Colour

Banksia, Persian Star, Chinese Fish and *Kaleidoscope* are just some of the rugs that rely on subtle colour shading. To organise the colour shading, collect all the shades that make the pattern and the colours that make the background. Arrange the shades so that they form a colour gradation, say deep pinks, light reds, scarlets, rusts and maroons, then back again to pinks. As the colours change in every row, the shading can be gradual if you place two close shades together and repeat this for a few rows or so.

I concentrated on shading the main pattern and kept the background simpler. The background still consists of many shades but generally all closer in tone, that is all dark or all light colours rather than variations of a colour.

As you work on the shading, hold your work up to a mirror to check on the development of the shading. The reverse image presents you with a fresh look at your work. Also, leave your work on display when not knitting, as this allows you to become familiar with the entire work and to see what shading variation you need to do next.

Different shades of colour are used for every row and a sequence of shades is repeated randomly to create gradual steps in shading.

Hems

Hems at the beginning and end of the one piece rugs allow the rug to lie flat. The fringed sides behave quite well.

Use smaller needles to cast on for the hem. Cast on fewer stitches than needed for the body of the rug. The hem is worked in rows of knit and purl to form stocking stitch. After the required length is complete a turning row is worked. This is a knit row after an odd number of rows, or a purl row after an even number of rows. It forms a ridge on the right side. Now change to the larger needles and increase the extra stitches as needed for the body of the rug along the first row. The increases can occur before the turning row if necessary. The procedure is reversed at the end of the rug.

CROCHET BORDERS

Some of the rugs have rounds of slip stitch crochet around them. Slip stitch is similar to chain stitch and resembles a knit stitch on its side and so makes an apt finish for the knitted piece. Slip stitch can only be worked in the round. If you turn and work back, a different pattern will result.

Have the rug blocked and dry before commencing. Begin at a corner. Place crochet hook through rug and pull out loop. Put hook through rug and pull out another loop and with the one movement pull this loop through the first loop. Put hook through rug again and pull through a loop and pull it through the loop on the hook, and so on. At each corner work three stitches into the one stitch. On the next round, put hook through the top loop of each stitch of the round before. Colours may be changed, but crochet must continue in the round. Weave in ends on wrong side. Press borders on completion.

Blocking

This is a relatively simple procedure. The rug needs to be completed, except for crochet borders which are done after blocking. Ensure all tails are woven in. Blocking 'sets' the wool and helps to prevent tails working loose.

You will need a clean paved area and lots of water. I used the floor of our shed quite satisfactorily. With lighter coloured rugs, I put a sheet on the pre-washed floor, but this precaution is not essential.

Lay the rug out flat and thoroughly wet it. If using a hose, don't have it on a strong pressure as this can cause matting. The rug should be saturated and heavy with water.

It is best to have two people to stretch medium to large rugs. The two people stand opposite each other and pull the rug, progressing gradually along all four sides. However it is possible for one person to

Blocking the Patchwork rug. First, the edges of the wet rug are straightened, then all of the seams will be straightened and walked on to flatten.

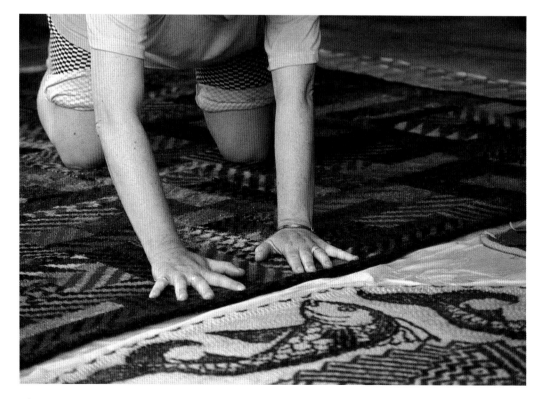

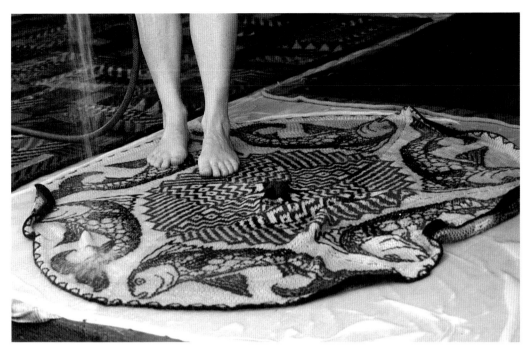

Wetting the Chinese Fish and walking on it to begin the stretching and flattening process.

do it alone. I found it easiest to walk barefoot and press the rug from the centre outwards. On occasions, I would be down on all fours pressing and pushing the rug outwards.

A sewn rug needs a few walks over all the seams to flatten them. If necessary, pour on more water as the weight helps to hold the rug flat.

Finally, align any patterns or seams and then the sides. Finger comb fringes straight and leave to dry.

Some rugs may need to be weighted down. Place bricks or other weights in plastic bags and position on corners or sides as needed.

Drying took three to four days — even on rainy days I was able to ensure a cross breeze. Avoid full, day-long sun as it may fade certain dyes. If full sun in unavoidable, either have the rug upside down or place a sheet over it. Full sun will not deteriorate the wool but may affect the dye. Some small rugs finished their drying over a line and were pressed later.

Once the rug is dry, crochet borders as necessary. Press borders and hems to give a neat finish.

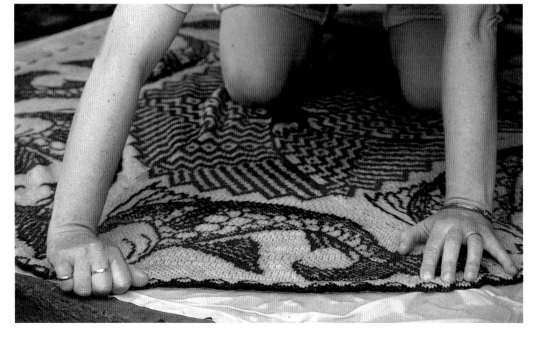

Stretching and flattening the hem.

17

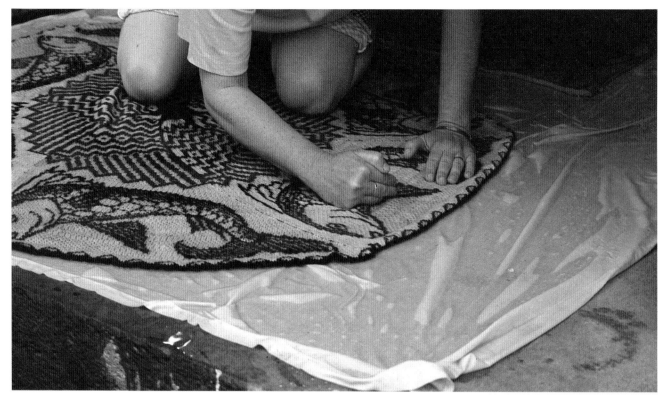

When stretching a circular rug, work from the centre to the outer edge.

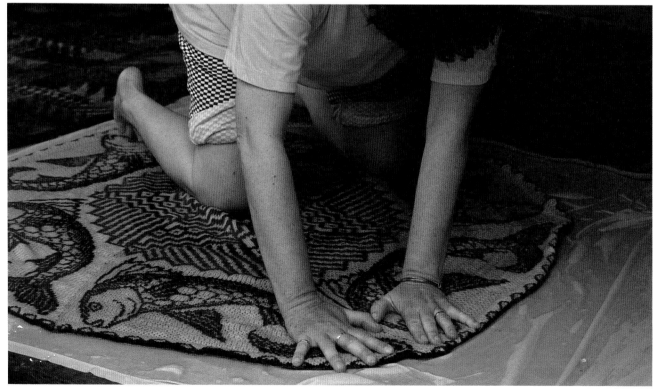

Place your knee on the centre to straighten each panel of a circular rug.

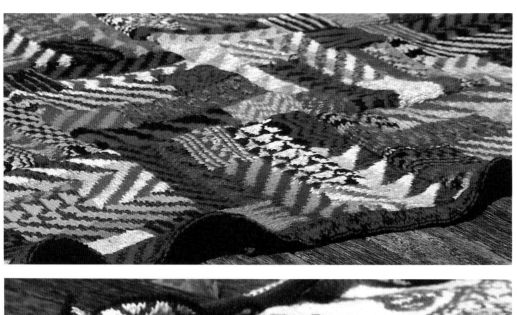

Unblocked patchwork rug, showing frilled hem.

Unblocked Chinese Fish, showing curled hem.

Unblocked Kaleidoscope, showing domed centre.

UNBLOCKED WORK

Your knitting does not emerge as a neat, straight, flat piece of work. Expect to see frills, bumps and curly edges. This is the nature of knitting, but it also has a compliant nature and will soon oblige you.

The photographs show *Patchwork* after sewing and before blocking. The hems frill and the seams do not lie straight. The two circular rugs shown in their raw state are also all frills and domed centres.

Take heart when your work resembles these photographs. Wetting and blocking will tame these problems into well-behaved pieces. Your final product will reward your efforts.

Sewing

Only two sewing stitches are needed. Slip stitch to sew down the hems and a running seam to join strips.

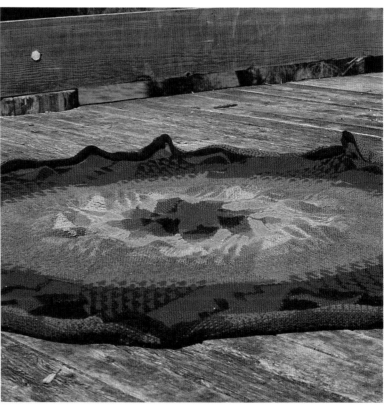

SLIP STITCH

This is a loose hemming stitch. When sewing hems on garments, this stitch should have as much stretch as the garment. For rugs, the hemming stitch may be pulled firmer. Secure yarn by working running stitches along hem edge first, then commence hemming. Finish off yarn by working running stitches back along hem.

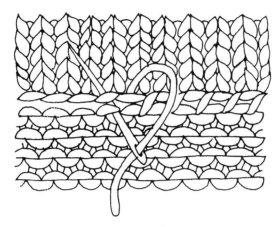

Slip stitch.

RUNNING SEAM

This stitch makes an almost invisible seam and is worked with right sides butted together. This makes it ideal for matching patterns.

Have the right sides of the two pieces facing you side by side. Secure the threads with running stitches down one side.

Left hand thumb holds the two pieces together. Take the sewing needle and pick up the loop that joins the first knit stitch to the second knit stitch. Pull yarn through firmly. Repeat this process onto the other side.

When seaming garments with this stitch, work a few centimetres then pull the seam so that the sewing thread stretches to match the garment's elasticity. Then continue with the next section of the seam and repeat the procedure.

Sewing the strips requires firm stitching but not so tight that the fabric is pulled in. The sewing thread becomes quite invisible as it beds down between the stitches. Always use a blunt point wool needle as sharp needles split the thread and make the seam uneven.

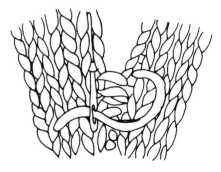

Running seam stitch.

Care and Cleaning of Rugs

The rugs can be treated as any other rug. Dry cleaning is possible. The rug can be washed if you have a tub or bath large enough to hold it. I have put large rugs outside and washed them with a wool wash product and lots of water. Some wool wash products need no rinsing which makes the process simpler. Knead the rug gently with hands, severe rubbing may mat the fibres. Then treat the rug as for blocking.

Linings

A non slip underlay is advisable, especially if the rug is to be on a hard surface. These underlays of synthetic foam material can be purchased by the metre and cut to shape with scissors. Some linings have a woven look which allows particles to fall through. The underlays reduce wear on the rug from abrasion.

Hopscotch

Here are two versions of a very versatile design. The chequerboard is a classic design that lends itself to a multitude of colour schemes and any size you require. Draw up your own chequerboard and play around with colours. The possibilities are infinite and your work will be unique.

MEASUREMENTS

118 cm x 134 cm

MATERIALS

Rug yarns. Other yarn may be substituted. Ensure all yarns are of uniform ply. Quantities are approximate.
1305 g beige
460 g brown
265 g tobacco
315 g blue/grey
220 g gold
120 g olive green
1 pair 4.5 mm needles
1 x 4.5 mm crochet hook

TENSION

14.5 sts. and 22 rows to 10 cm over stocking stitch using double yarn.

Notes:

1. Use all yarn double.
2. Slip the first stitch of every row to give a firm edge. However, do not slip the stitch when a new colour starts at the beginning of a row. (Slipping the stitch then will bring the last colour up into the new row.)
3. Use reef knots to join all colours. Weave all knots in only on completion of each strip. (Weaving in as you knit will change the smooth appearance of the stocking stitch.)
4. Follow the colour and assembly plan for each strip.
5. To make the rug larger or smaller, increase or decrease the number of stitches and rows. For example, 30 sts. and 46 rows or 10 sts. and 14 rows, or add more squares of the same size to the design.

Cottage Style

Knitted by Olive Threlfall

Use 4.5 mm needles and cast on 20 sts. in colour as given, and work in st.st.

Strips 1 and 9:

Cast on in tobacco. Work colours thus:
28 rows tobacco
196 rows brown
28 rows tobacco
Cast off.

The Cottage version of the Hopscotch rug.

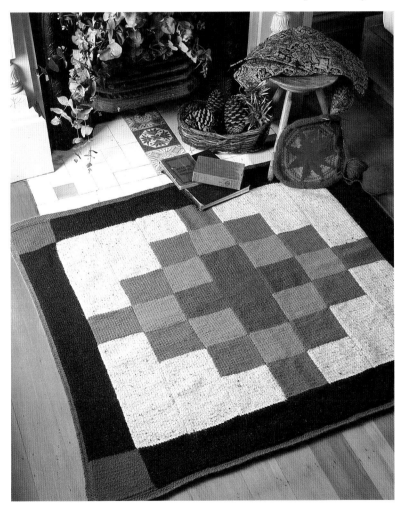

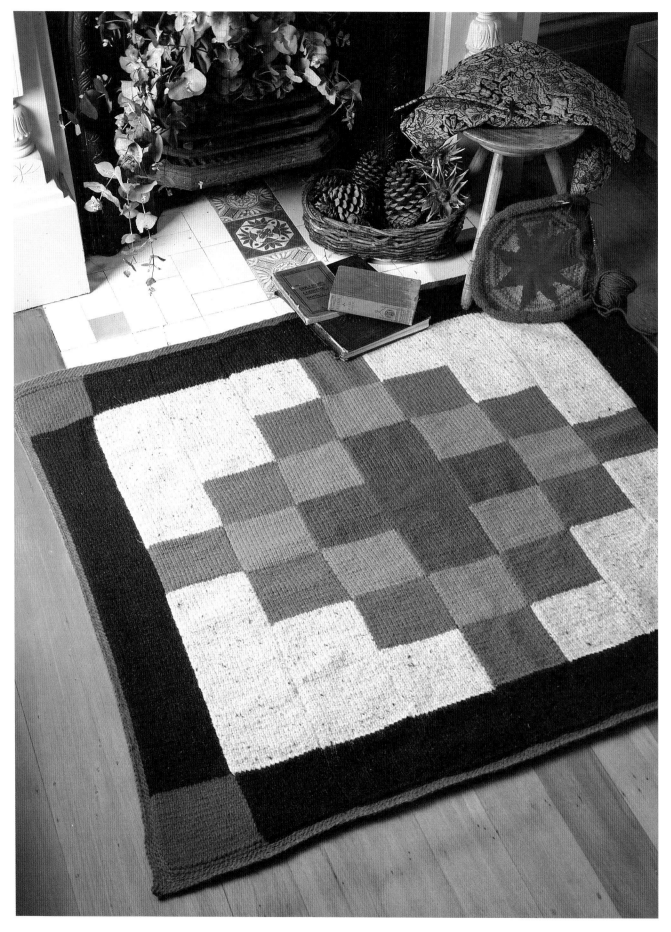

9	8	7	6	5	4	3	2	1
Tobacco	Brown	Brown	Brown	Brown	Brown	Brown	Brown	Tobacco
			Beige	Blue/grey	Beige			
		Beige	Blue/grey	Gold	Blue/grey	Beige		
	Beige	Blue/grey	Gold	Olive green	Gold	Blue/grey	Beige	
	Blue/grey	Gold	Olive green	Tobacco	Olive green	Gold	Blue/grey	
		Blue/grey	Gold	Olive green	Gold	Blue/grey		
			Blue/grey	Gold	Blue/grey			
Brown	Beige	Beige	Beige	Blue/grey	Beige	Beige	Beige	Brown
Tobacco	Brown	Brown	Brown	Brown	Brown	Brown	Brown	Tobacco

Colour and assembly plan.

Strips 2 and 8:

Cast on in brown. Work colours thus:
28 rows brown
84 rows beige
28 rows blue/grey
84 rows beige
28 rows brown
Cast off.

Strips 3 and 7:

Cast on in brown. Work colours thus:
28 rows brown

56 rows beige
28 rows blue/grey
28 rows gold
28 rows blue/grey
56 rows beige
28 rows brown
Cast off.

Strips 4 and 6:

Cast on in brown. Work colours thus:
28 rows brown
28 rows beige
28 rows blue/grey

24

28 rows gold
28 rows olive green
28 rows gold
28 rows blue/grey
8 rows beige
28 rows brown
Cast off.

Strip 5:

Cast on in brown. Work colours thus:
28 rows brown
28 rows blue/grey
28 rows gold
28 rows olive
28 rows tobacco
28 rows olive green
28 rows gold
28 rows blue/grey
28 rows brown
Cast off.

TO COMPLETE

Weave in loose ends. With right sides facing, use running stitch to join strips as shown in assembly plan, aligning the squares.

BLOCKING

Thoroughly wet piece. Stretch in both directions. Ensure it is straight. Allow to dry flat.

BORDER

With 4.5 mm crochet hook and blue/grey, work 7 rounds around all edges in chain st. crochet, putting 3 sts. into each corner every round.
Press borders using a damp cloth.

Teddy Bears' Picnic

Knitted by Caroline San Miguel

MEASUREMENTS

142 cm x 148 cm

MATERIALS

Rug yarn. Other yarns may be substituted.
Ensure all yarns are of uniform ply.
Quantities are approximate.

670 g grey	G
400 g pink	P
330 g apricot	A
255 g cyclamen	C
255 g yellow	Y
255 g lilac	L
115 g rust	R

1 pair 4.5 mm needles
1 x 4.5 mm crochet hook

TENSION

14.5 sts. and 22 rows to 10 cm over stocking stitch using double yarn.

Notes:

1. Use all yarn double.
2. Picture knitting is used to make the small chequerboard squares. Twist both colours around each other to avoid holes.

Teddy Bears' Picnic version of the simple Hopscotch pattern.

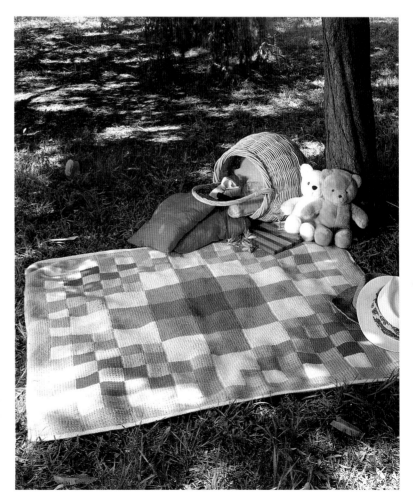

Teddy Bears' Picnic. Colour and assembly plan.

G Grey
P Pink
A Apricot
C Cyclamen
Y Yellow
L Lilac
R Rust

	G 20 sts	G 20 sts	G 20 sts	G 20 sts	G 20 sts	G 20 sts	G 20 sts	14r
Y	L Y	L Y	L Y	L Y	L Y	L Y	L Y	14r L
L	G R	G C	G 14r P	A 28r	P G	C G	R G	14r Y
Y	R G	C G	P 14r G	A 28r	G 10 sts P 10 sts	G C	G R	14r L
L	G C	G 14r P	A	P	28r A	P G	C G	14r Y
Y	C G	P 14r G	A	P	28r A	G 10 sts P 10 sts	G C	14r L
L	G 14r P	A	P	C	P	28r A	P G	14r Y
Y	P 14r G	A	P	C	P	28r A	G 10 sts P 10 sts	14r L
14r L	A 20 sts	P	C	R	C	P	28r A 20 sts	14r Y
14r Y	A 20 sts	P	C	R	C	P	28r A 20 sts	14r L
L	P 14r G	A 20 sts	P	C	P	28r A 20 sts	G P	14r Y
Y	G 14r P	A 20 sts	P	C	P	28r A 20 sts	P G	14r L
L	C G	P 14r G	A 20 sts	P	28r A 20 sts	G P	G C	14r Y
Y	G C	G 14r P	A 20 sts	P	28r A 20 sts	P G	C G	14r L
L	R G	C G	P 14r G	28r A 20 sts	G P	G C	G R	14r Y
Y	G R	G C	G 14r P	28r A 20 sts	P G	C G	R G	14r L
L 10 sts	Y 10 sts L 10 sts	Y 10 sts L 10 sts	Y 10 sts L 10 sts	Y 10 sts L 10 sts	Y 10 sts L 10 sts	Y 10 sts L 10 sts	Y 10 sts L 10 sts	14r Y 10 sts 10 sts
G 20 sts	G 20 sts	G 20 sts	G 20 sts	G 20 sts	G 20 sts	G 20 sts	G 20 sts	G 20 sts
9	8	7	6	5	4	3	2	1

3. Slip the first stitch of every row to give a firm edge. However, do not slip the stitch when a new colour starts at the beginning of a row. (Slipping the stitch then will bring the last colour up into the new row.)
4. Use reef knots to join all colours. Weave all knots in only on completion of each strip. (Weaving in as you knit will change the smooth appearance of the stocking stitch.)
5. Follow the colour and assembly plan for each strip. Each strip will show the number of sts. and rows to be worked in each colour.

Each strip:

With 4.5 mm needles and grey, cast on 20 sts. Work 14 rows.
Now refer to plan layout and tie in colours as needed. Small squares are 10sts. and 14 rows, while large squares are 20 sts. and 28 rows. On completion of each strip, cast off. Weave in loose ends.

TO MAKE UP

With right sides facing, use running seam stitch to join strips as shown in assembly plan, aligning the squares.

BLOCKING

Thoroughly wet piece. Stretch in both directions. Ensure it is straight. Allow to dry flat.

BORDERS

With 4.5 mm crochet hook and yellow, work 5 rounds of chain stitch crochet along all sides, putting 3 sts. into each corner in every round.
Press using a damp cloth.

Diamond Bright

Knitted by Liz Gemmell

This little footstool took on a new lease of life once the cover went on and it was literally knitted out of scraps — knots and all. The design is simple to follow and very easy to adapt for larger upholstery items as it repeats over 6 sts.

Experiment with various colour schemes to suit your decor.

The woven Fair Isle fabric makes perfect upholstery material. The fabric is firm, soft and elastic without being stretchy. Use garment wools, odd balls are ideal.

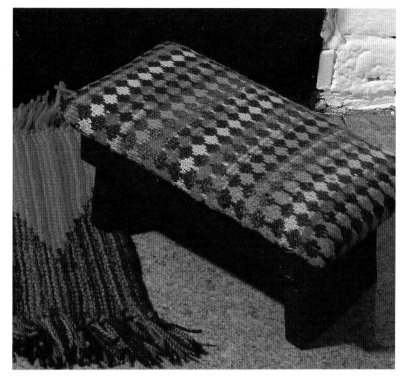

MEASUREMENTS

To fit 21 x 35 cm stool top.
Fabric 26 x 44 cm.

MATERIALS

8 ply garment wools.
Quantities are approximate.
50 g greens: bottle, teal, forest, emerald
50 g reds: scarlet, maroon, rust, orange, pinks
25 g blue
25 g purple
1 pair 3.25 needles
Polyester padding
Staple gun with heavy duty staples or upholstery tacks and hammer.

TENSION

30 sts. and 30 rows to 10 cm over pattern.

The Stool Cover

Prepare a ball of greens by joining varying lengths — 60 cm to 200 cm lengths; and a ball of reds — 20 cm to 100 cm lengths. Join with reef knots. Weave 2nd colour at every st. on K. and P. rows, making sure all knots are included.
With 3.25 mm needles and green, cast on 36 sts. Work in rows of K. and P. to make st.st. Work from graph for 114 rows.
Cast off.

TO COMPLETE

Weave in any loose ends.
Press using a damp cloth.
Fix padding on to stool top, and staple or tack piece to the underside of the stool.
Begin at a centre of one side and stretch to the other side. Work from centres to corners, folding fabric into a neat pleat at corners.

A footstool upholstered in the Diamond Bright pattern which is simple and quick to make.

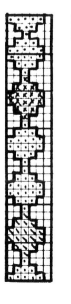

Greens

Reds

Blue

Purple

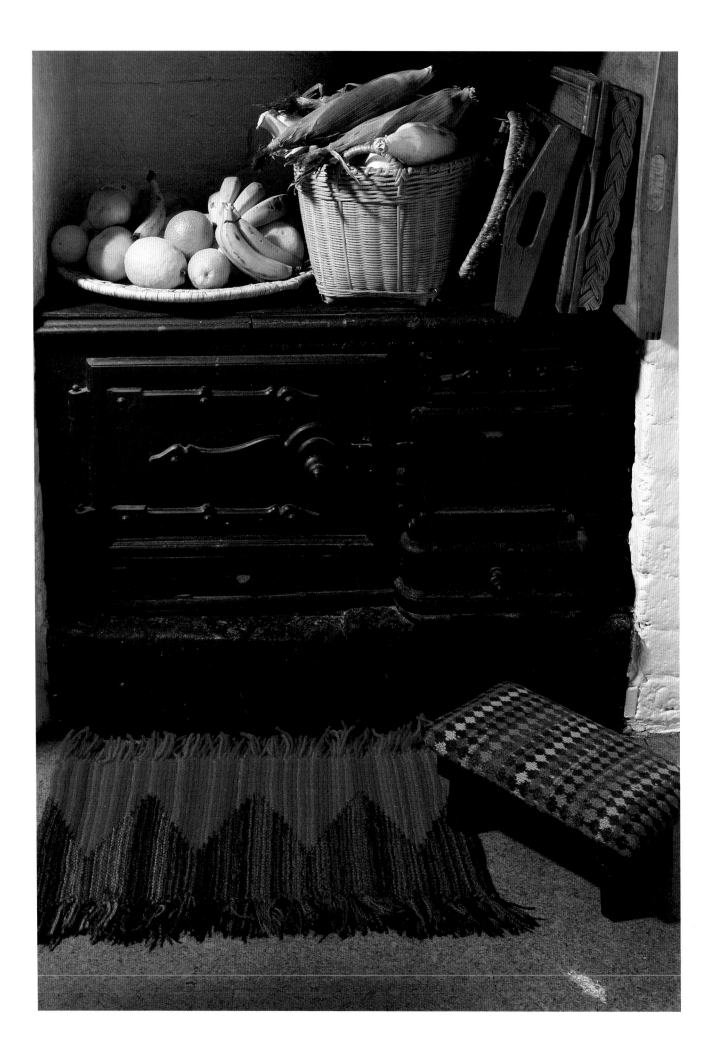

Welcome

Knitted by Liz Gemmell

A reversible door mat worked very easily entirely in garter stitch — knit every row. Like the footstool, it can be knitted from left-over wools. Use two yarns of similar tone together to get the subtle shades, and to give you the necessary thickness. The simple zig-zag pattern makes the design reversible. Remember that garter stitch will stretch and become longer, so allow for that in your measurements. Expect it to stretch 4 cm for every 10 cm of unstretched length.

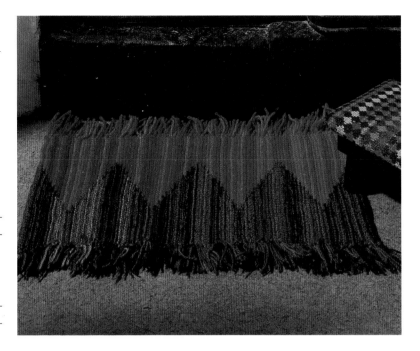

MEASUREMENTS

30 x 58 cm.

MATERIALS

Rug yarns. Other yarns may be substituted. Quantities are approximate.
150 g greens
150 g reds
1 pair 4.00 mm needles.

TENSION

17 sts. and 34 rows to 10 cm over garter stitch unstretched.

Note:

1. Fringe is made by cutting red and green yarns every return row. Make an overhand knot.

The Mat

With 4.00 mm needles and red, cast on 14 sts, tie in green and cast on 36 sts. in green — 50 sts. altogether. Cut green with 10 cm tail to form fringe.
Row 1: Tie in green, K.35 green, K.15 red, cut red to form fringe.
Row 2: Tie in red, K.16 red, K.34 green, cut green.
Row 3: Tie in green, K.33 green, K.17 red, cut red.

Row 4: Tie in red, K.18 red, K.32 green, cut green.
Continue in this manner until there are 14 green sts. and 36 red sts.
Next row, K. 1 st. green more and 1 st. red less until there are 14 sts. red and 36 sts. green.
Repeat pattern for length desired, cast off.

BLOCKING

Blocking to achieve full stretched length is optional as mat lies flat.
Thoroughly wet and stretch out. Place weights (covered in plastic) along edges to maintain length. Allow to dry.

Welcome — a cheery mat to make from odds and ends of wool.

Forest Flowers

Knitted by Olive Threlfall

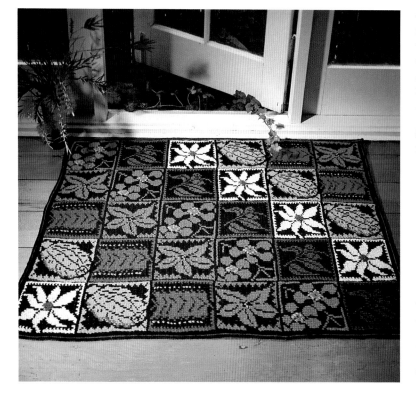

The Forest Flowers rug. As you can see, it can easily be made to any length or width.

Flowers from the Australian forests make wonderful designs for this small rug. I chose the flowers for their boldness of colour — the white flannel flower with its soft velvety centre, the golden wiry banksia, the fluffy red bottlebrush, shiny Geraldton wax, the brilliant bluebell, and our ubiquitous gum leaf. The rug is simply worked in long, narrow strips which are sewn together. This means that you can quite easily make your work as long and as wide as you wish.

As I was designing this piece, colour variations kept coming to mind. Still retaining the original colours of each flower, the backgrounds could be changed to navy, dark green or black. Or, using only one motif, for example the flannel flower, you could repeat several of these graphs across a row, instead of the long strips I've suggested.

By using smaller yarn, such as a 5 ply or 8 ply, smaller pieces can be made into table mats or cushion covers.

MEASUREMENTS

84 cm x 118 cm

MATERIALS

Rug yarns. Other yarns may be substituted. Quantities are approximate.
625 g black
125 g blue
165 g yellow
130 g pink
140 g red
120 g green
140 g white
1 pair 4.00 mm needles.
1 x 4.00 mm crochet hook.

TENSION

18 st. and 19 rows to 10 cm over pattern.

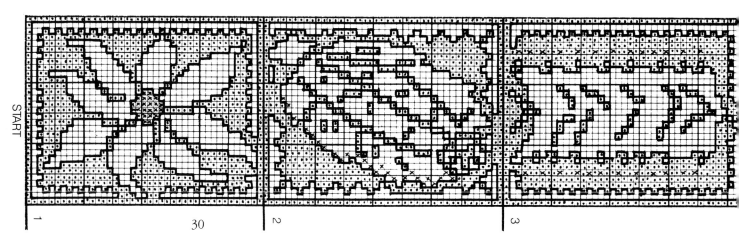

START

1

2

3

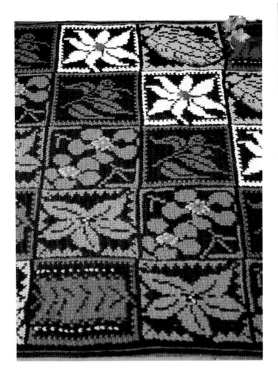

4	3	2	1	6
3	2	1	6	5
2	1	6	5	4
1	6	5	4	3
6	5	4	3	2
5	4	3	2	1

Colour plan.

The Strips

With 4.00 mm needles and black, cast on 31 sts.
Work Fair Isle st.st. in rows of K. and P. in order as shown in plan.
Weave in strands at back of work as you knit.
The third contrast thread is not taken across rows, but is carried up to required stitch.
Cast off on completion of 6 patterns.

BLOCKING

Weave in any loose threads.
Thoroughly wet piece, stretch in both directions to shape and allow to dry flat.

SEWING

Assemble strips as shown in plan.
Using running seam stitch, and with right side facing, place edges together and sew with black yarn.
Take care to match squares.

BORDERS

With 4.00 mm crochet hook and black yarn, work 3 rounds putting 3 sts. in every corner.
Then 1 round in pink (or your choice of contrast) and last round in black.
Press borders using a damp cloth.

- ● Black for each motif.
- ☐ 1 White ☒ Green
- ☐ 2 Yellow ☒ Red
- ☐ 3 Red ☒ Yellow
- ☐ 4 Blue ☒ Yellow
- ☐ 5 Pink ☒ Yellow
- ☐ 6 Green

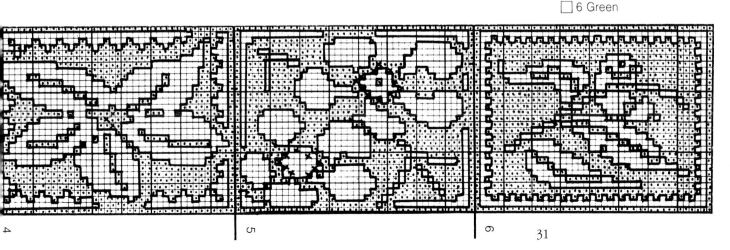

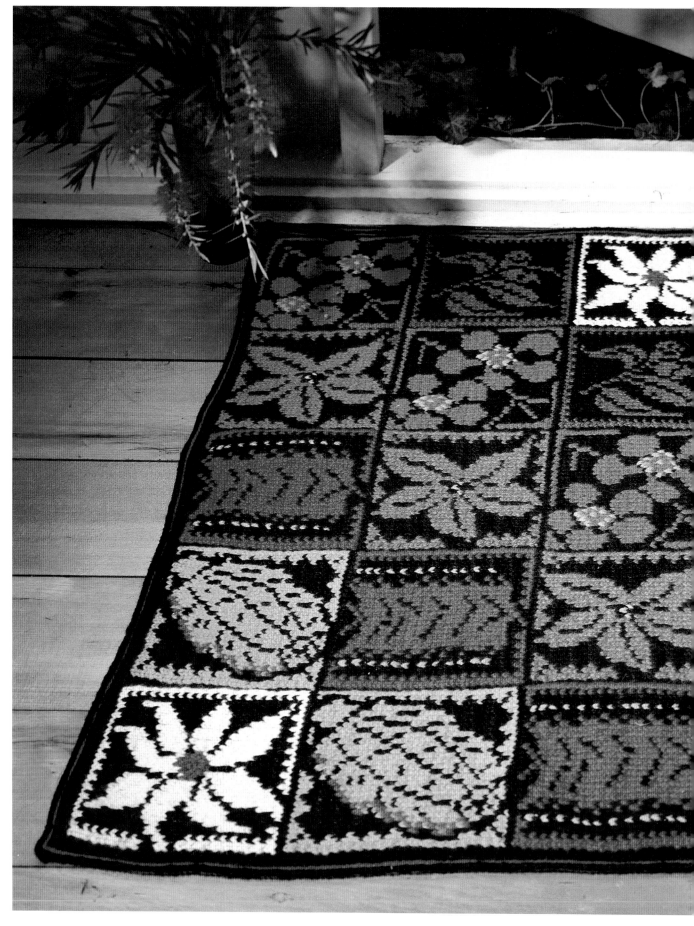

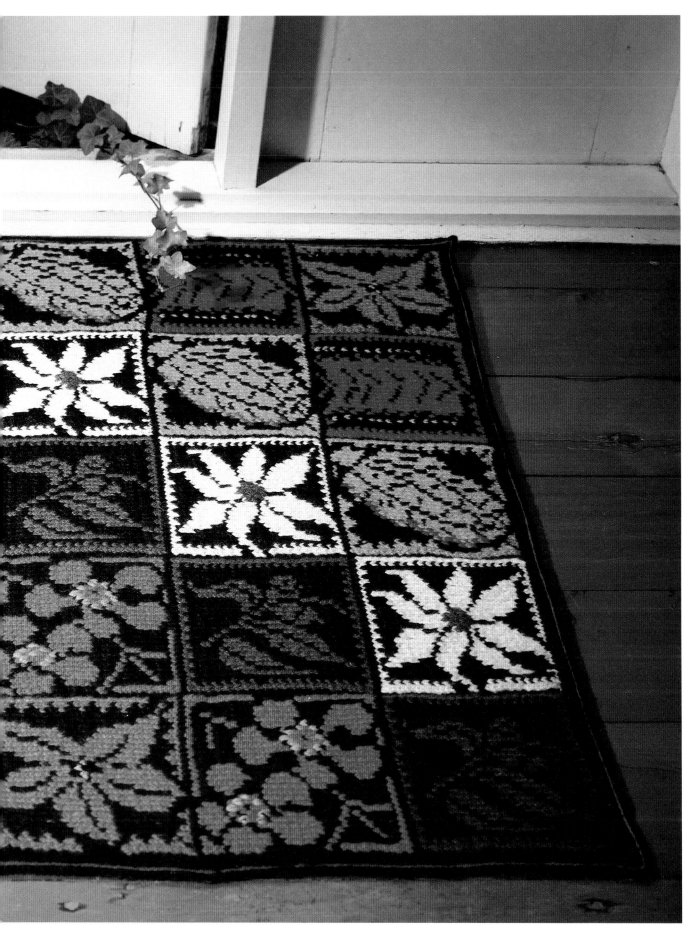

Child's Play

Knitted by Jean Perryman

A simple colourful rug with an easy design that's quick to knit. The pattern lends itself to a variety of colour schemes to complement any room.

Whichever yarn you use, make sure all is of identical ply or the rectangles and strips will not match up as comfortably.

MEASUREMENTS

98 cm x 112 cm

MATERIALS

Rug yarns. Other yarns may be substituted. Do ensure that all yarns are of uniform ply. Quantities are approximate.

Child's Play has a wonderful range of colours and is knitted in easy strips.

50 g red
160 g black
240 g royal
120 g dark green
120 g blue
180 g violet
60 g hot pink
70 g navy
140 g purple
120 g aqua
70 g rust
70 g turquoise
30 g bright green
40 g orange
30 g tan
40 g yellow
50 g bright red
20 g maroon
30 g light pink
20 g gold
1 pair 4.5 mm needles
1 x 4.5 mm crochet hook

TENSION

14.5 sts. and 22 rows to 10 cm over st. st. using double yarn.

Notes:

1. Use all yarn double.
2. Picture knitting is the method used in the two colour rectangles. Twist both colours around each other to avoid holes. All other colour changes occur at the beginning of a new row.
3. Slip the first stitch of every row to give a firm edge. However, do not slip the stitch when a new colour starts at the beginning of a row. (Slipping the stitch then will bring the last colour up into the new row.)
4. Use reef knots to join all colours. Weave all knots in only on completion of each strip. (Weaving in as you knit will change the smooth appearance of the stocking stitch.)
5. Two graphs are given to work the diagonal colour change rectangles. The graphs are not colour coded so that they may be used as required for the various colour combinations.
6. Follow the colour and assembly plan for each strip. When only one colour is given, use 2 strands of the same colour. When 2 colours are given, use 1 strand of each colour.

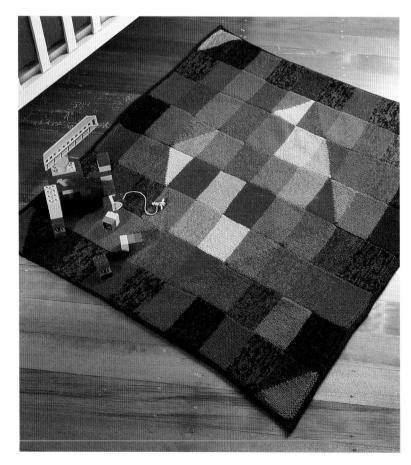

8	7	6	5	4	3	2	1
Red / Black Royal	Navy	Violet Black	Royal	Dark green Black	Violet	Blue Black	Orange / Dark green
Dark green	Blue	Royal blue	Aqua	Purple	Royal	Violet	Dark green Black
Blue Black	Purple	Dark green Turquoise	Violet Purple / Yellow	Bright green / Tan Orange	Aqua	Purple	Blue Royal
Royal	Royal Aqua	Bright green / Hot pink	Red	Bright red	Royal / Rust	Royal	Violet Black
Blue Black	Violet Purple / Rust	Orange Tan	Light pink	Rust	Hot pink	Turquoise Aqua / Yellow	Dark green
Violet	Red / Royal	Yellow	Maroon	Bright red	Gold	Rust / Purple	Royal Black
Dark green Black	Turquoise Royal	Bright red / Aqua Turquoise	Hot pink	Orange Tan	Light pink / Royal	Aqua	Violet
Royal	Dark green Turquoise	Violet Purple	Rust / Aqua Royal	Red / Bright green	Blue	Violet Purple	Blue Black
Violet Black	Aqua	Blue Royal	Dark green Turquoise	Purple	Violet Purple	Dark green Turquoise	Navy
Dark green / Hot pink	Navy Black	Violet	Royal Black	Navy	Dark green Black	Royal	Blue Black / Rust

| 8 | 7 | 6 | 5 | 4 | 3 | 2 | 1 |

Colour and assembly plan.

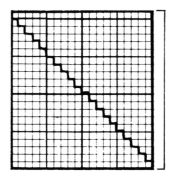
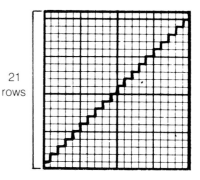

21 rows

7. To make the rug larger, make each rectangle bigger. Cast on more stitches, say 30 stitches and work 31 rows.

The Strips

With 4.5 mm needles and colour as shown for strip to be worked, cast on 20 sts.
Work K. for 2 rows before beginning first rectangle.
On completion of strip, work P. for 2 rows. Cast off.

TO MAKE UP

Weave in all loose ends.
With right sides facing, use running seam stitch to join all strips as shown in assembly plan.

BLOCKING

Thoroughly wet piece. Stretch in both directions. Ensure work is straight. Allow to dry flat.

BORDER

With 4.5 mm crochet hook and navy, work 4 rounds of chain stitch crochet around all edges, putting 3 sts. into each corner every round.
Press border using a damp cloth.

Patchwork

Knitted by Olive Threlfall

The patch could be an ideal way to introduce yourself to rug knitting techniques. The patch is a very simple geometric pattern and even though you repeat the same pattern each time, the colour schemes for each patch can be the same if you choose, but you can make them different for variety and interest. Whether the colours are different or the same, the assembly of the patches has infinite variations.

A single patch can be used as a cushion cover with a plain or simple design for the back, or as an upholstery piece. Worked in garment yarns and appropriate needles, a blanket for baby or adult bed could be assembled.

To accommodate all the colours, I made up large balls of each basic colour group. Each ball, for example blue, contained varying lengths of all the blues that I could collect from royal and teal, to sky. Each shade varied in length from 30 cm to 2 metres and was tied with reef knots. Sometimes two threads were used to make the equivalent ply rug yarn. I chose seven basic colour groups, but you could restrict yourself to as few as two colours, as long as you collect lots of shades and hues of each.

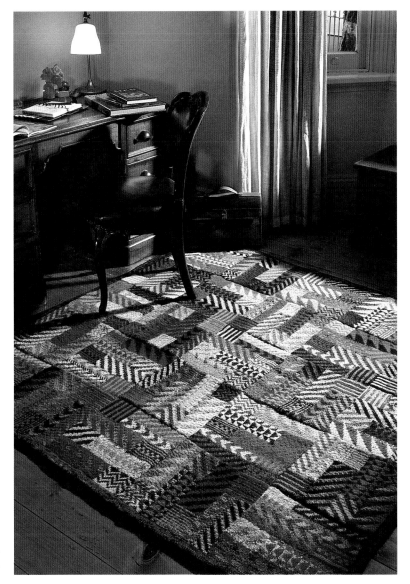

MEASUREMENTS

Each square 34 x 34 cm
Finished rug 178 x 178 cm, including hems.

MATERIALS

Rug yarns and assorted garment yarns. Quantities are approximate.
605 g gold: yellows, tobacco, beige, lemon, tan
735 g blue: royal, azure, ultramarine, bright, sky, teal
575 g green: emerald, bottle, dark, olive, aqua, nile
460 g pink: baby, apricot, sunset, dusty, hot, cyclamen, deep
500 g grey: blue, dark, steel, indigo, lilac
850 g black: navy, indigo, violet,
905 g red: scarlet, rust, cerise, maroon, plum
1 pair 4.00 mm needles
3 x 3.25 mm circular needles, 80 cm long

TENSION

18 sts. and 20 rows to 10 cm over pattern.

Notes:

1. Work the patch on 64 sts. as instructed, but adjust the number of rows at the end of the graph to make a square. Either work fewer rows than the 68 rows shown or more rows as needed. If you need to work more rows, simply continue the pattern as already established.

One simple patch is repeated to make a room-sized rug.

Patchwork colour plan.

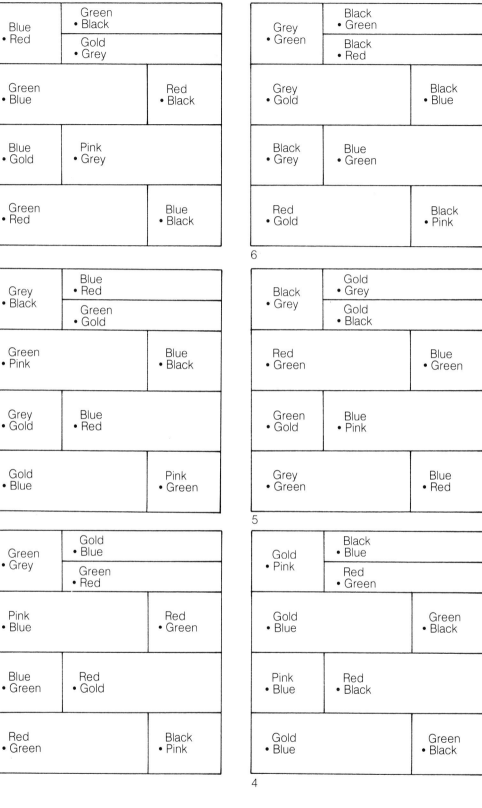

2. The colour plan shows that there are two sets of two colours each, that is four colours across each 16 rows. At the vertical colour change, twist both colours of A around both colours of B. By twisting both sets of colours around each other, the colour change is smooth and neat.

Always take both colours to the end of the row and twist around each other before starting the next row.

3. Work st. st. in rows of K. and P. Weave in all knots as you work as well as weaving in all strands at the back.

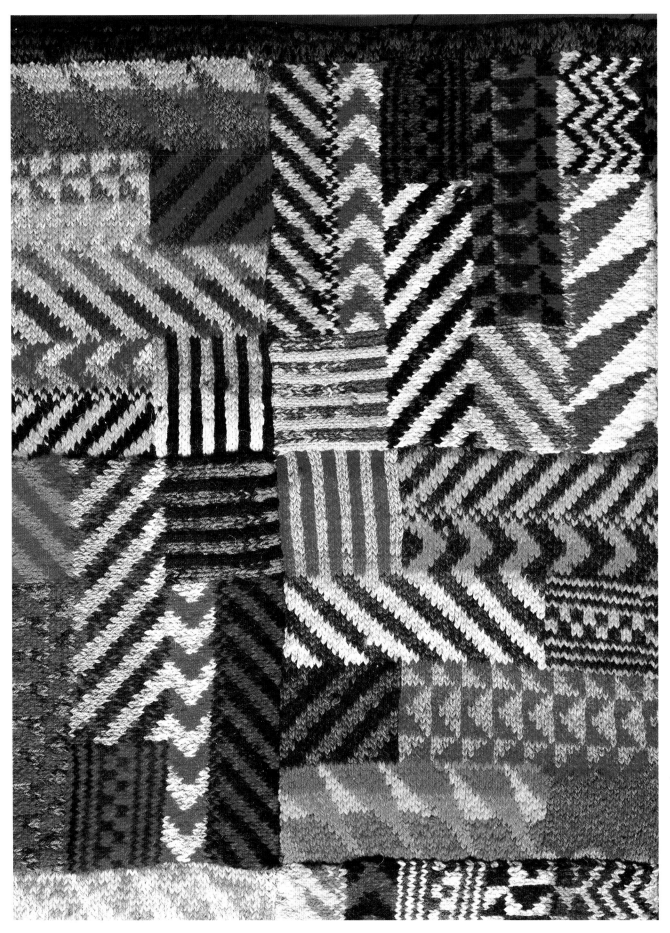

↑ 5	← 4	↑ 3	← 2	↑ 1
→ 4	↓ 3	→ 2	↓ 1	→ 6
↑ 3	← 2	↑ 1	← 6	↑ 5
→ 2	↓ 1	→ 6	↓ 5	→ 4
↑ 1	← 6	↑ 5	← 4	↑ 3

Patchwork layout.

The Patch

With 4 mm needles and a colour from the A section, cast on 64 sts.
Tie in 2nd A colour and patt. 20 sts. Tie in the two B colours and patt. to end.
Work from graph, changing colours at each new section as directed. Follow colour plan for each patch, rep. colour plans as required until 25 patches are completed. Number each patch as completed for easier assembly.

TO ASSEMBLE

Arrange patches as shown in layout, or as desired.
Sew patches into strips, then sew strips together.
With right sides facing, use running seam stitch to sew patches together.
Weave in loose threads.

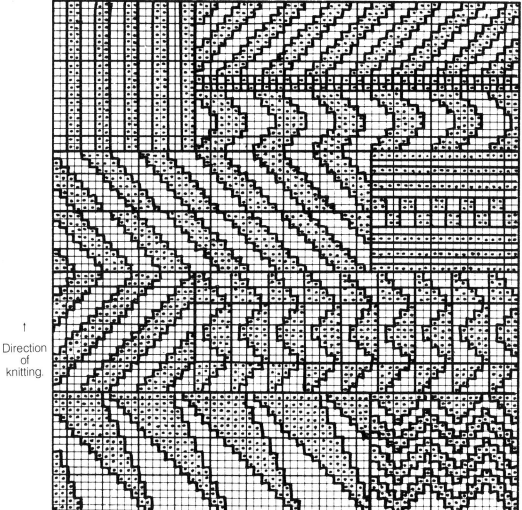

↑
Direction
of
knitting.

40

BLOCKING

Thoroughly wet piece.
Stretch each patch in both directions to form a square.
Stretch whole piece in both directions to form a square.
Flatten seams with pressure by walking over seams.
Allow to dry flat.

HEMS

With two 3.25 mm circular needles and black, pick up approx. 62 sts. along each patch — 310 sts. over 5 patches. Work st.st. in rows of K. and P. with 3rd needle.
Inc. 1 st. at each end of every row for 7 rows.
Knit 8th row to form turning ridge for hem.
Dec. 1 st. at each end of every row for 7 rows.
Cast off.
Work hem on opposite side of rug in black.
Work 2 remaining hems in red the same way.
Flat sew mitre corners.
Slip stitch hem in place.
Press hem and all seams if necessary using a damp cloth.

Patchwork variations.

↓	↓	→	←	↓	↓
↑	↑	→	←	↑	↑
→	←	↓	↓	→	←
→	←	↑	↑	→	←
↓	↓	→	←	↓	↓
↑	↑	→	←	↑	↑

6 x 6

↑	↓	↑	↓	↑
↑	↓	↑	↓	↑
↑	↓	↑	↓	↑
↑	↓	↑	↓	↑
↑	↓	↑	↓	↑

5 x 5

For this variation, knit patches in continuous strips.

→	↑	→	↑
↑	→	↑	→
→	↑	→	↑
↑	→	↑	→

4 x 4

→	↓
↑	←
→	↓
↑	←
→	↓
↑	←

2 x 6

Illusion

Knitted by Denise Gemmell

A mosaic of soft colours form this design. Though large, this piece is straightforward to knit and the result will create a whole new feel for your room.

Quantities are approximate.

2050 g lilac	L
1600 g pale apricot	A
800 g dark apricot	D
1150 g rust	R
800 g brick	B
400 g cinnamon	C
1200 g grey	G
1 pair 4.5 mm needles	
1 x 4.5 mm crochet hook	

MEASUREMENTS

170 cm x 315 cm

Eight strips make Illusion large enough to fill a room.

MATERIALS

Rug yarns. Other yarns may be substituted. Ensure all yarns are of uniform ply.

TENSION

14.5 sts. and 22 rows to 10 cm over st.st. using double yarn.

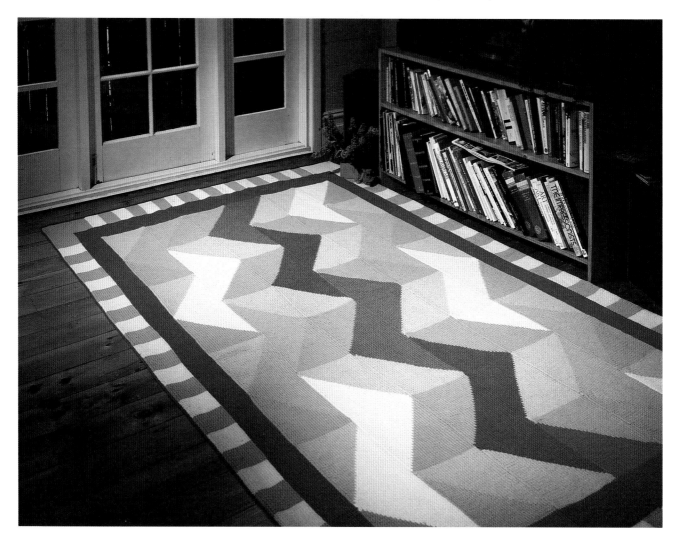

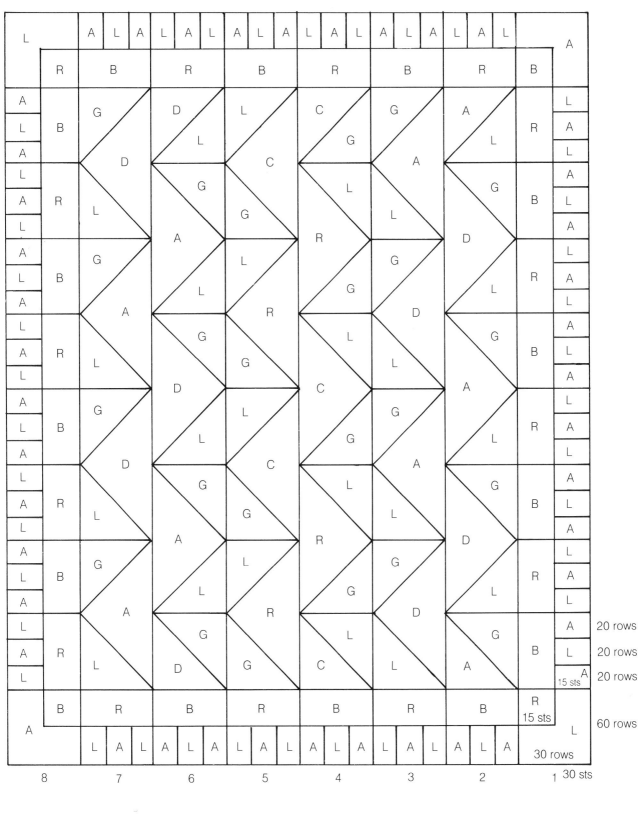

20 rows
20 rows
20 rows
15 sts

60 rows

30 rows

15 sts

30 sts

L Lilac B Brick
A Pale Apricot C Cinnamon
D Dark Apricot G Grey
R Rust

Assembly plan.

Notes:

1. Use all yarn double.
2. Picture knitting is used to form the diagonal and vertical colour changes. Twist both colours around each other to avoid holes in your work.
3. Two graphs are given to work the diagonal colour change rectangles. The graphs are not colour coded so that they may be used as required for the various colour combinations.
4. Use reef knots to join all colours. Weave ends in on completion of each strip. Roll up and number each strip for easy storing and identification.
5. Slip the first stitch of every row to make a firm edge. Do not slip the stitch when a new colour begins a row as this will bring the last colour up into the new row.

Strip 1:

With 4.5 mm needles and L, cast on 30 sts.
Work in st.st. for 30 rows, slipping first stitch of every row.
Row 31: Sl.1, K.14L, K.15R
Row 32: Sl.1 purlwise, P. all sts. in colours as they occur, twisting both colours at colour changes
Repeat these last 2 rows until 60 rows complete from beg.
Row 61: K.15A, K.15B
Row 62: As row 32
Row 63: Sl.1, K.14A, K.15B
Row 64: As row 32
Repeat these last 2 rows until 20 rows of A and B complete — 80 rows from beg.
Row 81: K.15L, K.15B
Row 82: As row 32
Row 83: Sl.1, K.14L, K.15B
Row 84: As row 32
Repeat these last 2 rows until 20 rows of L and B complete — 100 rows from beg.
Row 101: K.15A, K.15B
Row 102: As row 32
Row 103: Sl.1, K.14A, K.15B
Row 104: As row 32
Repeat these last 2 rows until 20 rows of A and B complete — 120 rows from beg.
The last 60 rows establishes the method of working the colours. Follow colour plan and complete strip in this manner. Cast off.

Strip 2:

With 4.5 mm needles and A, cast on 30 sts.
Row 1: K.10A, K.10L, K.10A
Row 2: Sl.1 purlwise, P. all sts. in colours as they occur, twisting both colours at colour changes.
Row 3: Sl.1, K.9A, K.10L, K.10A.
Row 4: As row 2
Repeat these last 2 rows until 30 rows complete from beg.
Work 30 rows B, slipping first st. in every row, except for the first row.
Row 61: K.30A
Row 62: As row 2
Row 63: Sl.1, K.1G, K.28A
Row 64: As row 2
Row 65: Sl.1, K.2G, K.27A
Row 66: As row 2
Cont. in this manner, inc. G sts. and dec. A sts., following the appropriate graph as guide, for 60 rows.
Follow colour plan, changing colours as required and using graph as guide, until strip is complete. Cast off.
Work all remaining strips in a similar manner.

TO MAKE UP

Weave in loose ends.
With right sides facing, join all strips following plan layout using running seam stitch.

BLOCKING

Thoroughly wet piece. Stretch in both directions. Ensure it is straight. Allow to dry flat.

BORDER

With 4.5 mm crochet hook and R, work 3 rounds of slip stitch crochet around all sides, putting 3 sts. in every corner.
Press edges, using a damp cloth.

Cosmos

Knitted by Olive Threlfall

The motifs for this table cover or floor piece come from all over the world.

I've included an Austrian star, birds from Germany, Arabia and Russia, and traditional geometric designs from Persian carpets, as well as several motifs from different parts of the British Isles.

This piece creates a lot of interest for the knitter with its variety and diversity of patterns.

The hexagonal shape is ideal for draping over a table.

MEASUREMENTS

240 cm x 240 cm.

MATERIALS

Rug yarns. Other yarns may be substituted. Quantities are approximate.

It is desirable to use as many shades of each colour as possible.
210 g light green
240 g dark green
65 g bright green
150 g blue grey
150 g light grey
250 g maroon
260 g royal blue
170 g blue
400 g navy
200 g golden ochre
460 g red
290 g black
140 g gold
130 g khaki
1 pair 4.00 mm needles
1 x 4.00 mm crochet hook

TENSION

20 sts. and 20 rows to 10 cm over pattern.

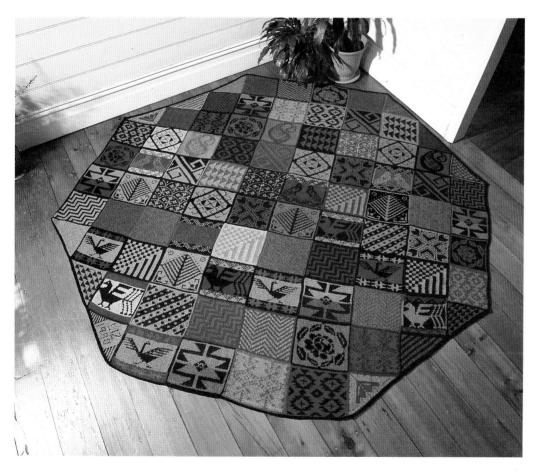

A hexagonal rug or table cover made from Fair Isle strips with a multitude of motifs.

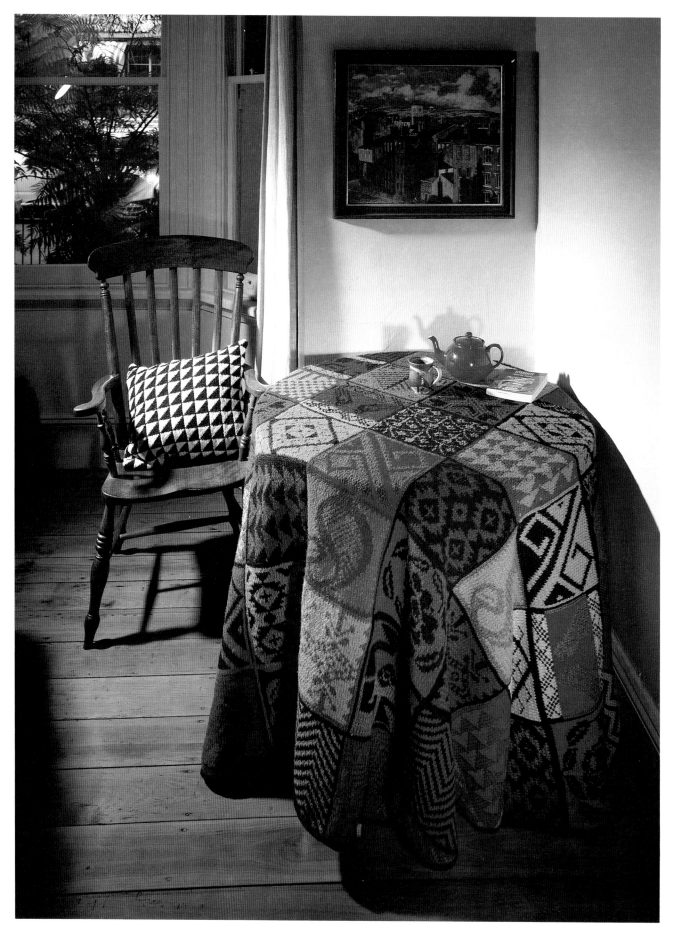

E F

Gold / Bright green • (E)	Red / Blue • 4	Navy / Gold • 12	Dark green / Red • 2	Blue / Red • 10

Red / Blue/grey • (F)

B

Light grey / Maroon •	Navy / Red • 12	Light green / Navy • / Maroon / Blue • 3	Ochre / Blue/grey • 11	Gold / Navy • 1	Navy / Red • 9	Gold / Maroon • 18

Light green / Blue • (E)

F

Ochre / Blue •	Blue / Red • 18	Blue / Black • 11	Red / Navy • 2	Blue / Red • 10	Navy / Red • 18	Light grey / Khaki • 8	Ochre / Dark green • 17	Red / Black • 10

Light grey / Maroon • (D)

Dark green / Light green • 1	Gold / Navy • 17	Blue/grey / Gold • 10	Blue / Maroon • 1	Khaki / Red • 9	Ochre / Dark green • 17	Red / Navy • 7	Navy / Ochre • / Blue / Gold • 16 / Navy / Ochre •	Blue/grey / Maroon • 9	Red / Navy • 4

Red / Navy • 2	Gold / Dark green • / Red / Blue/grey • 16 / Gold / Dark green •	Navy / Ochre • 9	Blue / Gold • 18	Maroon / Light green • 8	Light green / Black • / Red / Navy • 16 / Bright green / Black •	Gold / Blue • 6	Black / Light green • 15	Red / Khaki • 8	Red / Dark green • / Black / Ochre • 3

Ochre / Navy • / Black / Red • 3	Gold / Navy • 15	Dark green / Light green • 8	Ochre / Black • 17	Red / Navy • 7	Red / Dark green • 15	Dark green / Gold • / Navy / Red • / Dark green / Gold •	Navy / Ochre • 14	Gold / Dark green • 7	Navy / Red • 2

Ochre / Navy • 4	Blue / Red • 14	Red / Blue • 7	Navy / Light green • / Red / Blue • 16 / Navy / Light green •	Ochre / Light Grey • 6	Blue / Khaki • 14	Blue / Maroon • 4	Gold / Black • / Red / Black • 13 / Gold / Black •	Light green / Maroon • 6	Blue / Gold •

D

Light green / Ochre •	Red / Black • / Gold / Black • 13 / Red / Black • 6	Ochre / Navy • 6	Dark green / Gold • 15	Maroon / Gold • / Red / Black • 5 / Maroon / Gold •	Red / Navy • / Gold / Navy • 13 / Red / Navy •	Gold / Navy • / Khaki / Maroon • 3	Blue / Red • 12

Dark green / Red • / Navy / Ochre • 5 / Dark green / Red •

Red / Black • (C)

C

Maroon / Ochre •	Red / Blue • / Gold / Blue • 5 / Red / Blue •	Light green / Maroon • 14	Blue / Red • 4	Light green / Red • 12	Red / Black • 2

Red / Bright green • 11

Maroon / Khaki • (B)

B

Light green / Dark green •	Blue / Red • / Ochre / Navy • 13 / Blue / Red •	Ochre / Dark green • / Navy / Red • 3	Gold / Blue/grey • 11	Red / Navy • 1

Blue / Gold • (A)

Cosmos colour plan.

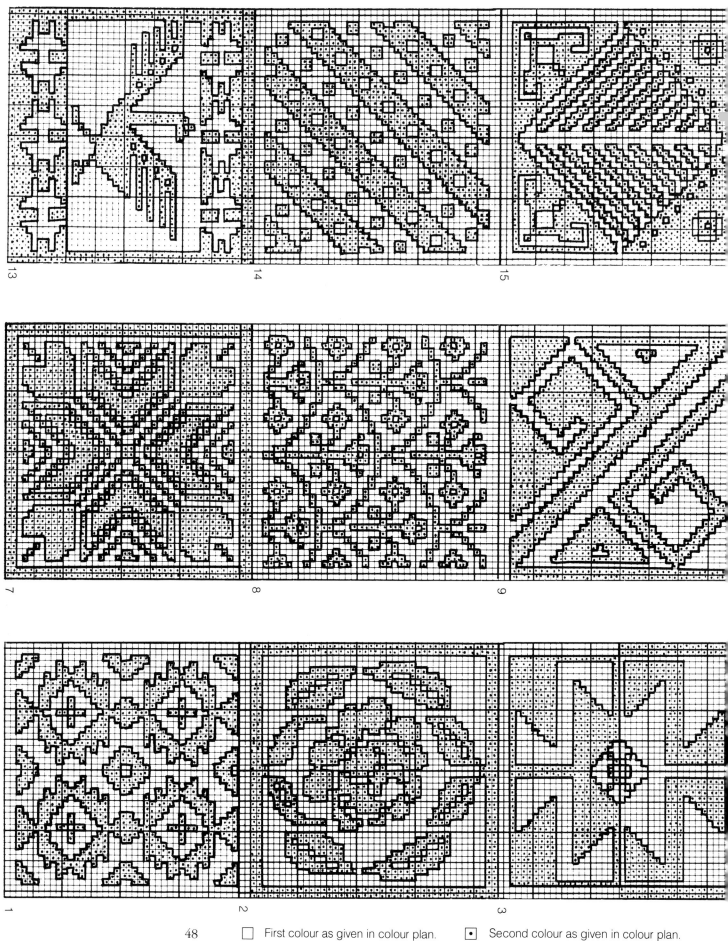

☐ First colour as given in colour plan. ⊡ Second colour as given in colour plan.

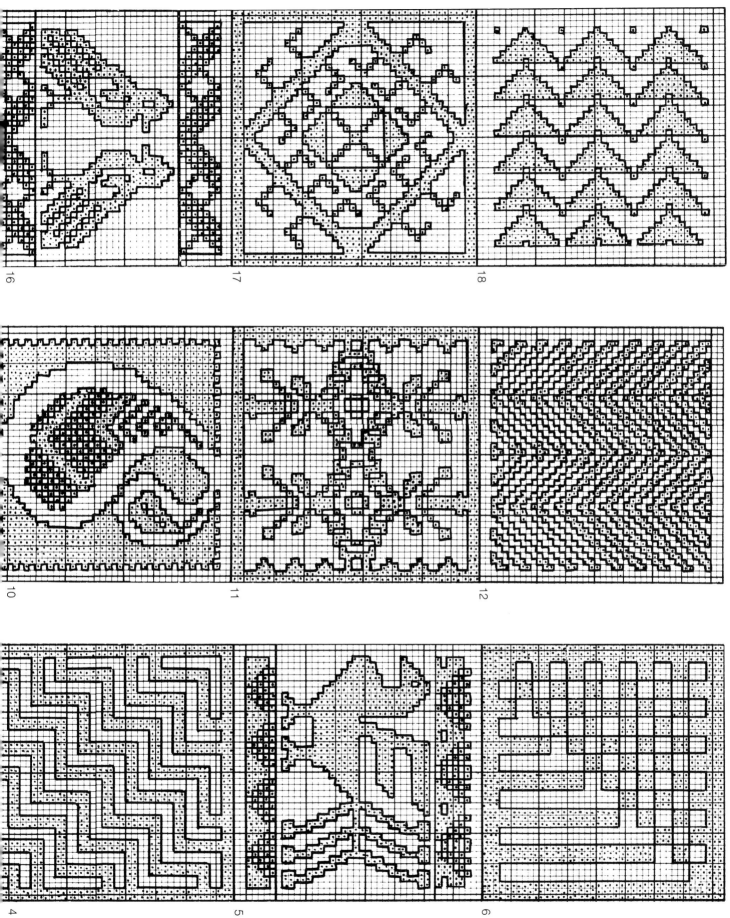

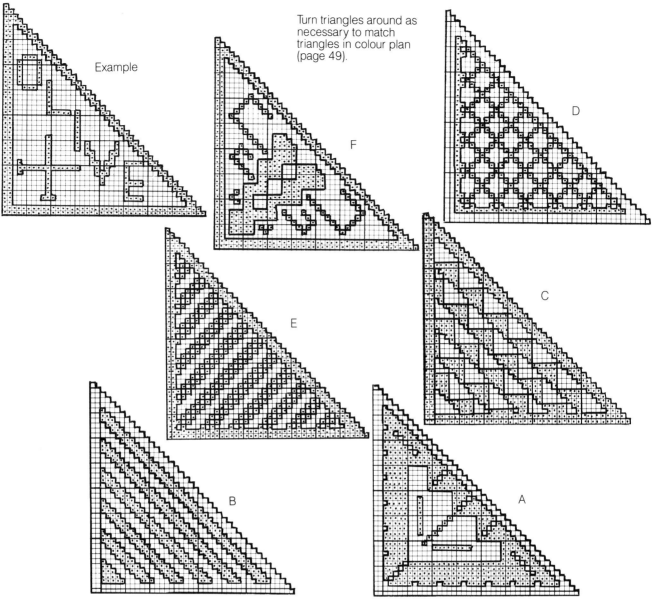

Example

Turn triangles around as
necessary to match
triangles in colour plan
(page 49).

F

D

E

C

B

A

VARIATIONS

1. Rug may be knitted to any size and also
need not be hexagonal. As it is worked in
strips, any length can be knitted, thus
making this an ideal design to use for a
hall runner.
2. Each motif can be taken separately and
repeated for cushion covers, upholstery
pieces, placemats, etc.
3. Of course, colours can be changed to your
own scheme.

Notes:

1. Rug is worked in strips following the
layout as shown.
2. Layout shows sequence of motifs and
colour.
3. In the original piece, the knitter worked
her name into a triangle. I've given you

the graph of that has an example for you to
follow. Another triangle in the rug has my
name and date worked in. Substitute graph
have been given as replacement for these
two triangles.

Squares:

Each square is 42 sts. wide and 42 rows long.
Patterns are worked in st.st., K. and P. rows.
All threads at the back are woven in.

Triangles:

For triangles that start with a point, make 1
st. and inc. 1 st. either at beg. or end of every
row until 42 sts. Thus triangles A, B, and C
will be increased at beg. of every K. row and
at the end of every P. row. Triangles B, C, and
C, will be increased at end of every K. row
and beg. of every P. row.

Triangles with a flat base start with 42 sts. and are decreased by 1 st. every row until 1 st. remains to be fastened off.
Graphs for triangles can be simply turned until the position matches your requirements.
Knit 10 strips following colour plan.

TO MAKE UP

Following colour plan, assemble strips in order. With right sides facing, sew strips together using running seam stitch.

BLOCKING

Thoroughly wet work.
Pull in both directions until shape becomes symmetrical. Dry flat.

EDGES

With crochet hook and navy yarn, work 4 rounds of chain st. crochet, placing 3 sts. at each corner every round.
Press edges using a damp cloth.

TWO TABLE MATS

Knitted by Liz Gemmell

The patterns used in *Cosmos* were too interesting to use just once. I've used two of the motifs to create table mats. With a bit of calculating, you could adapt any of the motifs to be used as mats or upholstery pieces.

A traditional Arabic bird motif has been used for the first mat while the motif for the second mat comes from old Russian embroidery pieces.

Motifs from the Cosmos rug can be used for place mats.

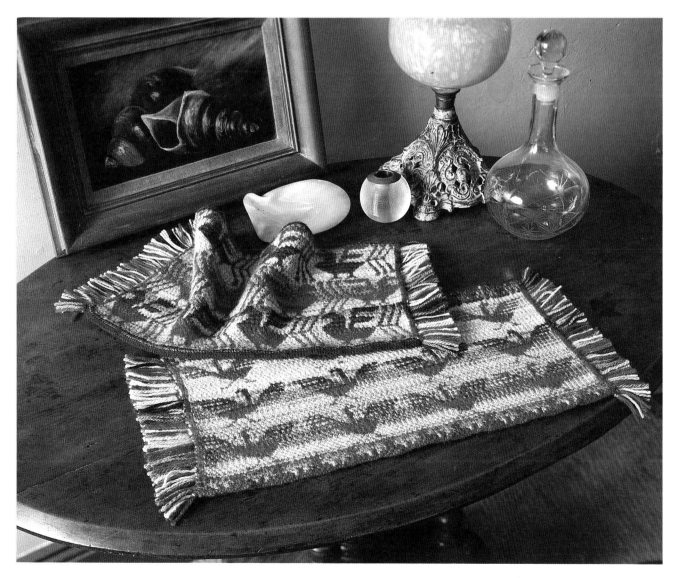

MEASUREMENTS

30 cm x 45 cm

MATERIALS

8 ply wool — various quantities.
75 g rusts: maroon, rusts, deep tan, red/brown, burgundy
75 g greys: blue/grey, light grey, green/grey, fawn
1 pair 3.00 mm needles.

TENSION

32 sts. and 36 rows to 10 cm over pattern using 3.00 mm needles.

Arabic Bird Mat

With 3.00 mm needles and rust, cast on 136 sts. Work rows of K. and P. st.st. for 4 rows.
Next row inc. 20 sts. evenly along row to 156 sts.
Next row K. to form turning ridge for hem.
Begin working in K. rows only, forming a fringe at both ends of row. Use overhand knots to form fringe.
Work border pattern taken from *Cosmos*, the 13th motif. Border is 13 sts. repeated along row 12 times for 8 rows.

Beg. working bird pattern. Use the centre 38 sts. repeated 4 times across row with 2 sts. as edge at beg. and end of each row — 156 sts. Work the first 22 rows of bird pattern as first band.
For second band, reverse position of bird. Beg. reading graph from left to right. Work 22 rows.
Last band, repeat original band of birds.
Finish off with same border pattern as beg.
Work 1 row P. rust as turning ridge for hem.
Next row dec. 20 sts. along row.
Work 4 more rows st.st.
Cast off.

TO COMPLETE

Slip stitch hems into place.
Press using a damp cloth.

Russian Bird Mat

Cast on and work hem and turning ridge as for first mat.
Begin working in K. rows only, forming a fringe at both ends of row. Use overhand knots to form fringe.
Work 1 row maroon, 1 row grey, 1 row maroon. Begin working *Russian Bird* pattern. Instructions for *Arabic Bird* mat apply. On completion of three rows of birds, finish off with the first 3 rows, then complete as for first mat.

Al Fresco

Knitted by Olive Threlfall

This is an ideal way to revive a tired director's chair. Spruce up the timber work and simply slip the back cover on and place the padded mat over the canvas seat.

Experiment with your own colour schemes and you'll be pleased with your efforts.

I recommend garment wools as these are more comfortable to the touch. You will need to measure the back and seat of the chair you are using to make sure your knitted pieces will fit. The padded mat can be easily made smaller or larger, simply by changing the number of blue rows and stitches surrounding the square inner pattern. The back cover could be adapted to slip over conventional chair backs. As its design is in multiples of 10 sts., making a smaller or larger cover is very easy. Simply repeat the middle 10 sts. by 10 rows pattern (blue and white triangles) to achieve the desired length.

MEASUREMENTS

Chair Back: when folded in half, 20 cm length x 51 cm wide.
Padded Seat Cushion: 40 x 51 cm.

MATERIALS

8 ply garment wools
150 g white
250 g blue
1 x 3.00 mm circular needle, 80 cm long
1 x 3.75 mm circular needle, 80 cm long
Foam piece 40 x 51 cm, washable.

TENSION

24 sts. and 26 rows to 10 cm over pattern using 3.75 mm needles or whichever needles will give the correct tension.

Chair Back

With 3.00 mm circular needle and blue, cast on 243 sts. Work in K. and P. rows to form st.st. for 2 cm, ending on a K. row.

Next row K. to form turning ridge for hem.
Next row inc. to 270 sts. thus: *K.8, inc. in next st.: rep. from * to end.
Join into a round. Tie in coloured marker to show beginning of rounds. Knit in rounds for 2 cm.
Change to 3.75 mm circular needle and work from graph noting that graph begins with 5 rounds of blue.
Weave in second colour when working over 5 or more sts; carry up rounds when knitting only single colour rounds.
On completion of graph, cast off loosely.

TO COMPLETE

Weave in any loose threads.
Slip stitch hem into place.
Fold cover in half and flat sew cast off edges together, leaving openings at both ends for chair back supports to come through.
Press work using a damp cloth.

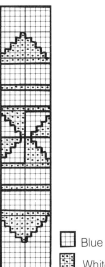

☐ Blue
▨ White

Al Fresco gives a deck chair a new lease of life.

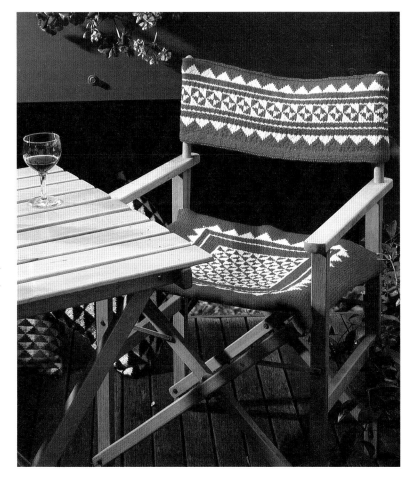

53

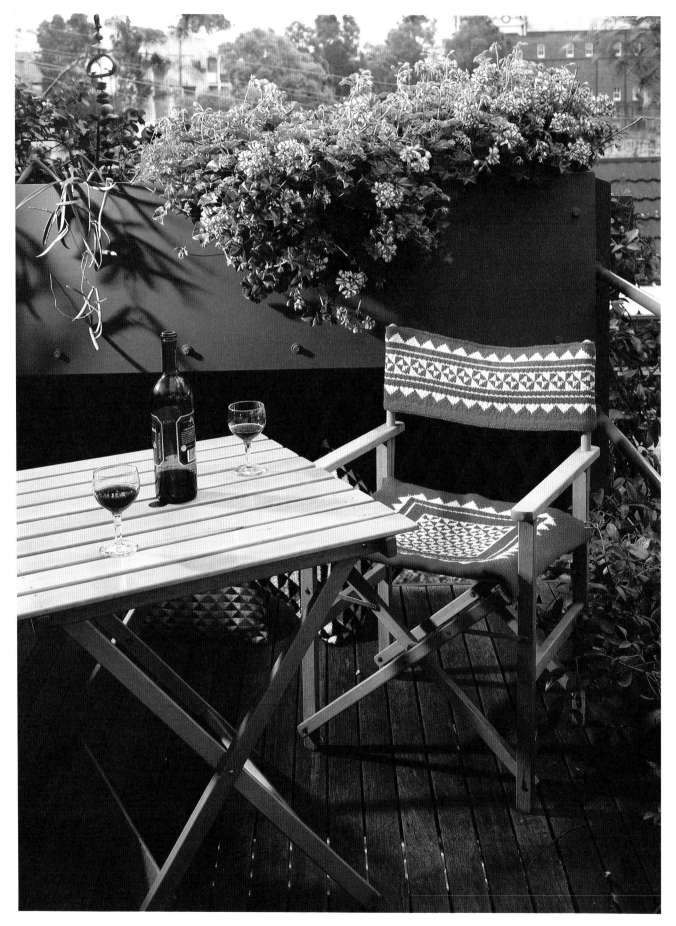

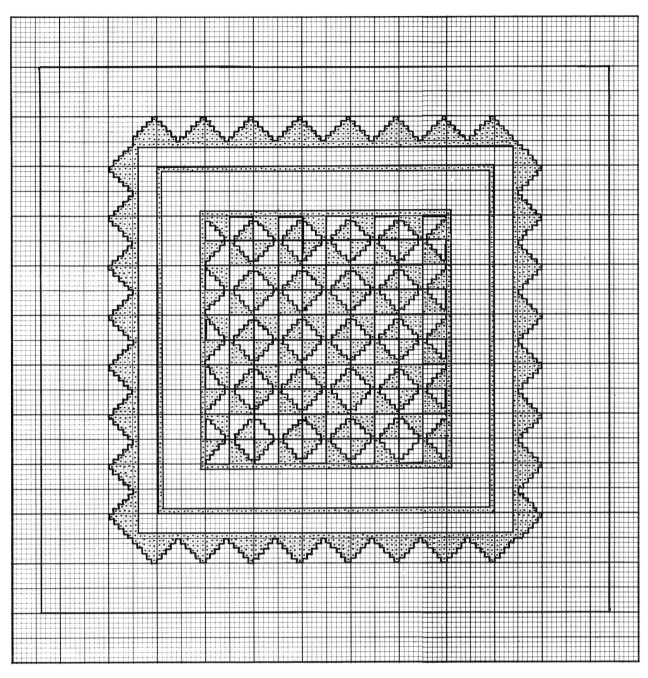

Padded Seat Cushion

With 3.75 mm needles and blue, cast on 118 sts. (or required sts. according to your own measurements and tension test) and working in rows of K. and P., follow graph.

Note:

Length of cushion can be adjusted by knitting more or less than the 10 rows shown. If an adjustment has been made at this stage, remember to match the number of rows after the inner pattern.
On completion of graph, work 110 rows (or number of rows required as before) to form back of cushion.
Cast off.

TO COMPLETE

Weave in any loose ends.
Press piece using a damp cloth.
With right sides facing, back stitch both sides.
Turn work to right side.
Insert foam.
Flat sew cast on and cast off edges together.

☐ Blue

▦ White

True Blues

Knitted by Olive Threlfall

☐ White
⊡ Navy

☐ Pales
⊡ Blues

The very simple triangles create a dazzling effect on these two cushions in a collection of blue shades. Seen here are just the two cushions, but you could use the two patterns over and over again using many different combinations of blues to create a wonderful collection.

Patterns taken from the small rug *Harlequin* will provide you with more designs to knit up as cushions.

Use soft garment wools and needles just one size smaller than recommended to give a closer fabric.

Instructions are the same for each cushion.

MEASUREMENTS

46 x 46 cm.

MATERIALS

8 ply garment wools
1. Navy and White
 200 g navy
 200 g white

2. Multi-blues
 200 g pale blues — white, grey, sky, nile green
 200 g mid-blues — royal, teal, indigo, violet
1 pair 3.75 mm needles
2 x 30 cm zips in matching colours
2 cushion fillings.

TENSION

24 sts. and 24 rows to 10 cm over pattern.

Notes:

1. For the multi-blue cushion, both colours, pales and mid blues, change every 5 rows, or as you choose.
2. Weave strand in at the back when working over 5 or more sts.

The Cushions

With 3.75 mm needles and blue, cast on 120 sts. and work in st.st.
Work from graph until a square shape is formed.
Tie in contrast markers and rep. patt. to make back of cushion.
Cast off.

TO MAKE UP

Weave in loose ends.
Press work using a damp cloth.
Flat sew cast on and cast off edges from sides to centre, leaving 30 cm open for zip.
With right sides facing, use matching sewing thread and back sew zip into opening.
Open zip, turn cushion to inside and back stitch sides using matching yarn.
Turn cover to right side and insert cushion filling.

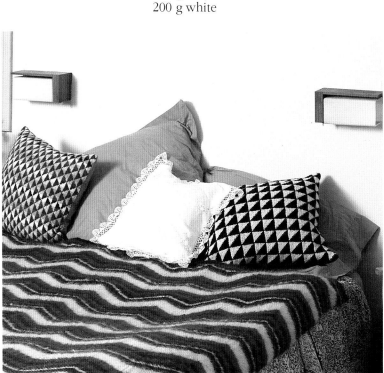

Rainbow Runner

Knitted by Olive Threlfall

This is a traditional design adapted from a Persian Kelim for which I chose all the colours of the rainbow: you could choose colours to suit your colour scheme.

The length of the runner is made by the stitches while the short width is made by the rows. This puts the fringe at the 'top' and 'bottom' of the runner as is the tradition with woven rugs.

MEASUREMENTS

74 cm x 240 cm including fringe
74 cm x 230 cm without fringe

MATERIALS

Rug yarns. Other yarns may be substituted. Quantities are approximate.
1200 g reds, oranges, yellows, pinks, purples
1700 g blues, greens, navies
4 circular needles 3.25 mm, 80 cm long.
4 circular needles 4.00 mm, 80 cm long

TENSION

17 sts. and 25 rows over pattern using 4.00 mm needles.

The Runner

With 3.25 mm circular needles and blue cast on 365 sts. Divide sts. on to 3 needles, K. with the 4th needle. Work K. and P. rows of st.st. for 3 cm, ending on a K. row. Next row K. to form turning ridge of hem.
Change to 4.00 mm circular needles and work only in K. rows forming a fringe at both ends. Read section on page 12 dealing with fringes for details.
Begin working from Chart A and at the same time inc. 19 sts. evenly along first row thus: K.4, * inc. in next st., K.18; rep. from * to end — 384 sts.
Graph B has patterns organised thus: K.16 sts. triangle pattern, rep. next 32 sts. 11 times (or desired length), K.16 sts. triangle pattern.

The first and last 16 sts. form a border pattern.
In length, work 5 repeats of the 32 row pattern or width required. Shades of colour are placed at random or to your plan.
Finish off with Chart C. Along last row of Chart C dec. 19 sts. thus: K.4, *K.2 tog., K.18: rep. from * to end — 365 sts.
Change to 3.25 mm circular needles and work 1 P. row as turning ridge of hem.
Work in rows of K. and P. and in blue for 3 cm
Cast off loosely.

TO COMPLETE

Check knots for even tension.
Retie knots if necessary.
Slip stitch hems into place.

BLOCKING

Thoroughly wet piece. Stretch in both directions to shape.
Allow to dry flat.
Press hems using a damp cloth.

CHAIR UPHOLSTERY

Knitted by Liz Gemmell

The fabric made by using the woven Fair Isle method lends itself beautifully to upholstery. The woven stranding at the back gives the fabric strength and thickness with just enough elasticity for ease. Use soft garment wools as these are kinder to the touch and durable.

You will need to have the dimensions of your required upholstery fabric. I needed a piece 45 cm wide by 40 cm long. If necessary you may need to do some stitch and row adjustment to get your required dimensions.

I used smaller needles than for the footstool. This gave me the crisp delineation of pattern I wanted while still being comfortable to use.

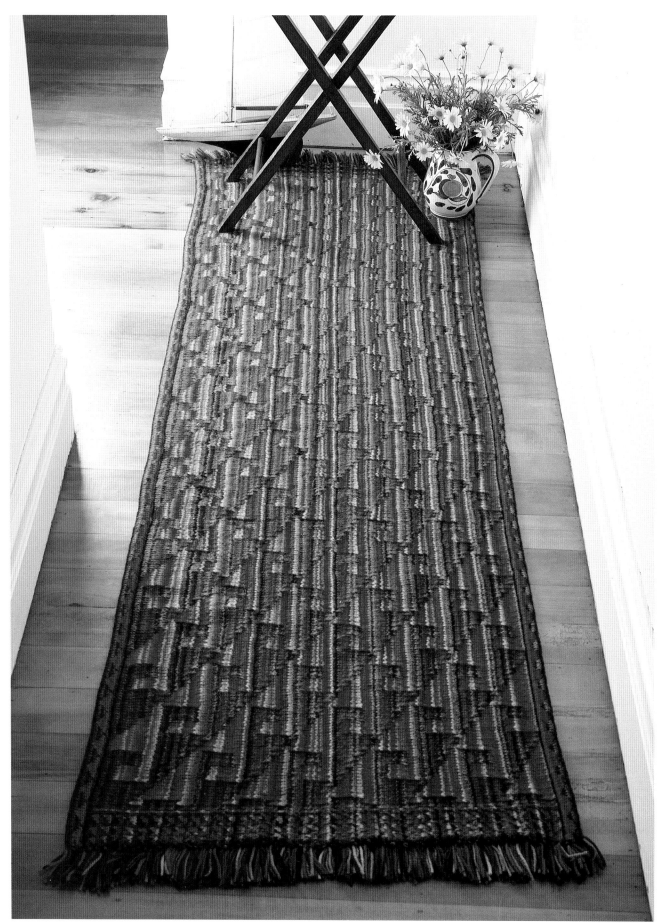

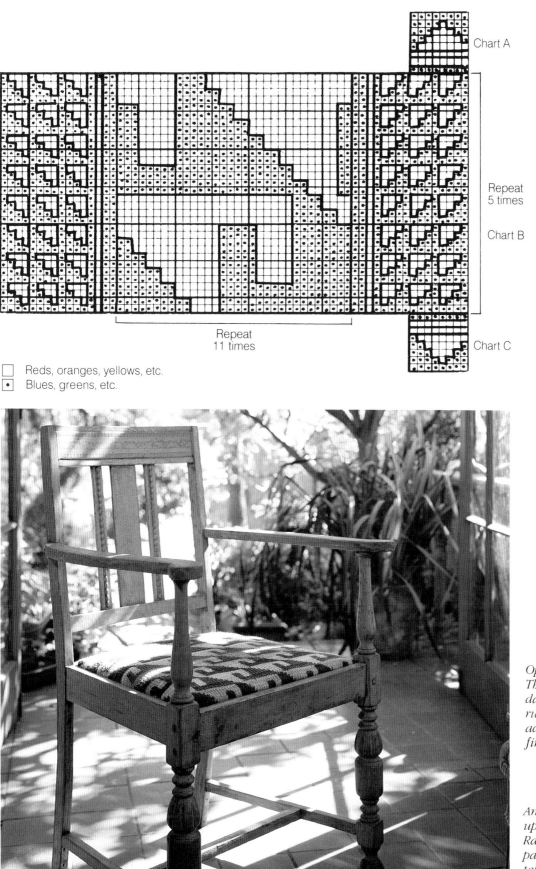

Chart A

Repeat
5 times

Chart B

Repeat
11 times

Chart C

☐ Reds, oranges, yellows, etc.
⊡ Blues, greens, etc.

Opposite page:
The rainbow colours
dance across this hall
runner. The design is
adaptable to larger or
finer projects.

An old chair
upholstered with the
Rainbow Runner
pattern. The pattern
takes on a new look
when different colours
and smaller yarns are
used.

59

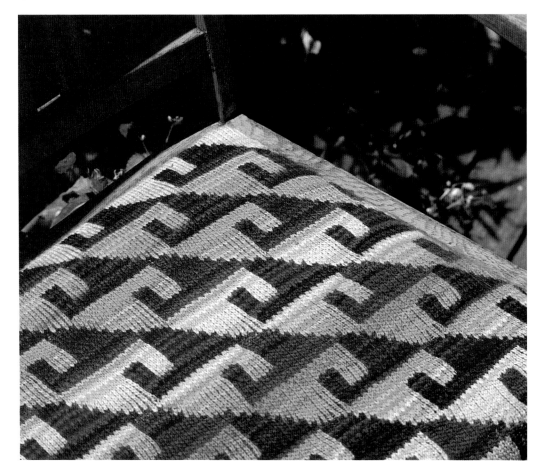

MATERIALS

8 ply garment wools — various quantities.
100 g dark: navy, charcoal, indigo, olive, dark green, brown, dark blue
100 g light: beige, green, golds, tan, corals, light brown
1 x 3.00 mm circular needle.

TENSION

32 sts. and 36 rows to 10 cm over patterns using 3.00 mm needles.

The Piece

With 3.00 mm needles and dark, cast on 160 sts. Use the central 32 sts. and 32 rows of the *Rainbow Runner* chart.
Work in K. rows only, weaving in every stitch.

Tie reef knots at both ends of row.
Change colours every row.
Work to desired length. Cast off.

BLOCKING

If piece is small enough, place a clean folded sheet and/or towel on floor or ironing board.
Have rustless pins on hand.
Thoroughly wet piece, stretch in both directions.
Place on sheet and pin to shape.
Allow to dry.

Upholstery

If preferred, sew zig zag machine stitches or back stitch by hand around upholstery shape. Stretch and tack to furniture item as required.

Flashpoint

Knitted by Liz Gemmel

Simple geometric lines and shapes float on a dotted background. The colours are really tones, light and dark. Each tone has a large variety of colours and shades. The whole effect is of strong outlines on a tweed ground.

The repeat graph is easy to adapt to larger or smaller rugs, mats or upholstery pieces.

MEASUREMENTS

117 cm x 157 cm approximately (not including fringe).

MATERIALS

Rug yarn and 12 ply and 8 ply garment yarns.
2600 g dark colours
1200 g light colours
These quantities are only approximate and may vary between individual knitters.
2 circular 3.25 mm needles, 80 cm long.
3 circular 4.00 mm needles, 80 cm long.

TENSION

22 sts. and 23 rows to 10 cm square over pattern using 4.00 mm needles.

Geometric patterns flash across a tweedy background. Make the fringe long and luxurious to contrast with the crisp motifs.

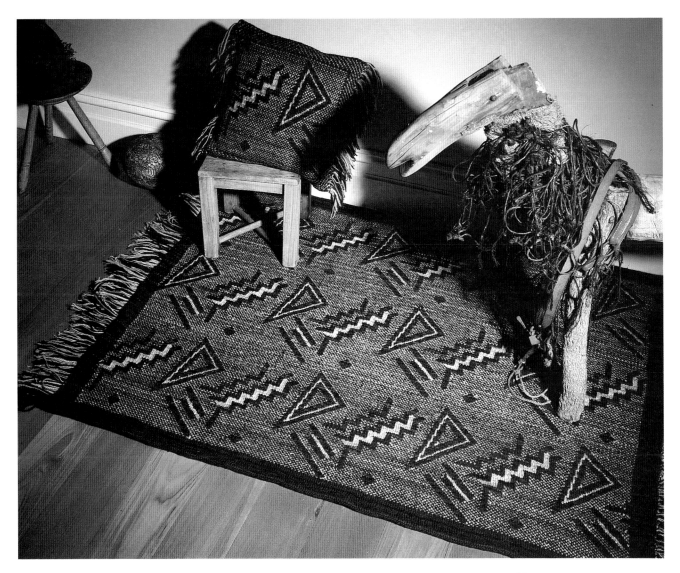

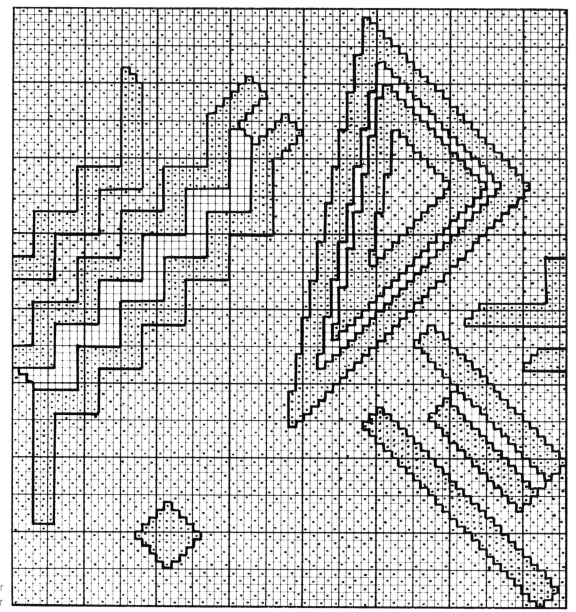

• Dark colour
□ Light colour

COLOURS

The dark colours include navies, browns, deep greys and black.

The light colours are a lot more varied. Colours should include beige shades, from biscuit to taupe; pink shades, from dusty to lilac; blues from sky to aqua; and greys. All should be of a very light tone.

The dark colours are used in random order, while the light colours are often worked in subtle gradations of colour, though they may also be used in random order.

If you choose to use only 2 colours — for example, navy and beige — the whole effect will be completely different. The soft tweedy look will go and instead you will achieve a crisp and precise appearance. The choice is yours.

YARNS

Rug wool is slightly thicker than 12 ply wool. To create equivalent yarn from garment wool, I used a 12 ply and 8 ply together or 2 x 8 ply strands. Using 2 strands allows you more versatility in blending colours such as putting pink and blue together (or pink and grey, or lilac and grey, etc.).

TECHNIQUE

Woven Fair Isle is used across all the solid dark and light areas. All the remaining stitches are worked as one stitch dark, one stitch light, thus giving a third tone for the background.

To give a neat surface appearance to the background, always put one colour on the top and the other stranded at the bottom (e.g. light on top and dark stranded at the bottom). This system produces parallel stranding, and keeps the stitches on the fabric surface regular.

The Rug

With 3.25 mm circular needles and a ball of dark, cast on 287 sts. Work in stocking st. (1 row K., 1 row P.) for 8 rows.
P. next row to form hem edge.
Change to 4.00 mm needles and inc. along row thus: K.3, inc. in next st., *K.6, inc. in next st., rep. from * to last 3 sts, K.3 — 328 sts.
Use a different colour for every row and work in K. rows only, making a deep fringe at the side. Refer to general instructions of woven Fair Isle and overhand knots to form the fringe.
Work 14 rows as border in dark.
Next row: Using light and dark colours, K.12 dark, begin reading from graph. Place 4 repeats of patt. across row, tying a marker of coloured thread to show each patt. rep. Work to last 12 sts, K.12 dark.
The first and last 12 sts. form the dark border.
Cont. in this way until 3 reps of patt. are complete.
Work 13 rows of dark colour.
Next row dec. sts. thus: K.3, K.2tog., *K.6, K.2 tog., rep. from * to last 3 sts, K.3 — 287 sts.
Work 1 P. row.
Change to 3.25 mm needles and work in stocking st. for 8 rows. Cast off.

TO COMPLETE

Check knots, retie if necessary.
Wet and block, and dry flat.

FLASHPOINT CUSHION

Knitted by Liz Gemmell

The colours, yarns and technique are the same as for the floor rug. Read these details before you start.
The cushion uses the same graph as the rug and a separate graph for the all-round border.

The front is knitted with a fringe at each side. The back is worked as a continuation of the front, but in a diagonal pattern and in rows of K. and P. to eliminate the fringe. Dark and light colours will be changed every few rows or so.

MEASUREMENTS

43 cm x 43 cm approximately (not including fringe).

MATERIALS

Rug yarns various 12 and 8 ply yarns
300 g dark colours
300 g light colours
These quantities are only approximate and

Flashpoint has a matching floor cushion with a simple border.

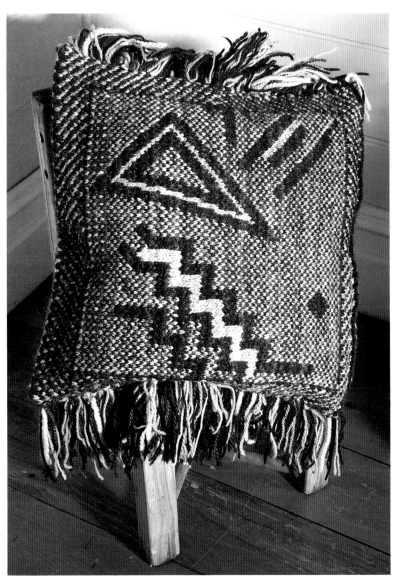

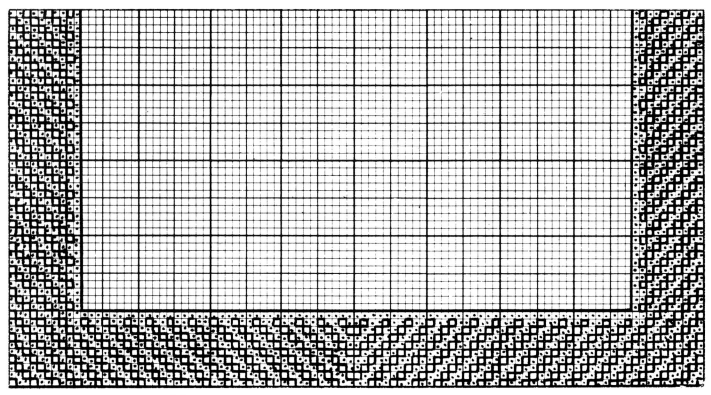

Border of Flashpoint cushion which fits the rug graph exactly.

☐ Dark colour
☐ Light colour

Back of Flashpoint cushion.

Assembly of Flashpoint cushion.

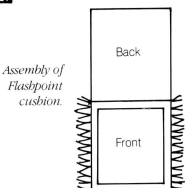

may vary between individual knitters.
1 circular 4 mm needle, 80 cm long
1 34 cm zip fastener
Cushion filling

TENSION

22 sts. and 23 rows to 10 cm square over pattern using 4.00 mm needles.

The Cushion

With 4.00 mm circular needle and dark, cast on 96 sts.
Work border patt. for 9 rows.
Row 10: 10 sts. border patt., 76 sts. of rug graph, 10 sts. border patt.
Cont. as established until border patt. is complete.
You will now be half way through rug patt.
Turn graph of border patt. upside down and cont. to end.
On completion of front, work in K. and P. rows and work patt. for back. Change dark and light colours at random until 98 rows are complete.
Cast off.

TO MAKE UP

Trim fringe.
Wet and block, and dry flat.
Flat sew the cast-on and cast-off edges together from sides, leaving opening for zip fastener.
Sew zip fastener into place, using backstitch.
With wrong sides together, flat sew side seams, leaving fringe free.
Insert cushion filling.

Harlequin

Knitted by Liz Gemmell

Simple shapes and lots of your favourite colours make a combination that's actually fun to knit. Patterns and colours change often, giving the knitter signs of quick progress and the viewer plenty of interest. A small delightful rug that will enliven any room.

MEASUREMENTS

105 x 62 cm without borders
118 x 75 cm including borders

MATERIALS

Rug yarns. Other yarns may be substituted. Quantities are approximate
50 g aqua
50 g teal
50 g royal blue
50 g acid blue
50 g emerald green
50 g olive green
50 g dark green
100 g gold
50 g yellow
100 g red
50 g rust
50 g dark apricot
50 g cyclamen
50 g deep pink
50 g purple
50 g violet
50 g grey
200 g black
3 circular 4.00 mm needles, 80 cm long

TENSION

18 sts. and 21 rows to 10 cm over pattern

Notes:

1. The rug was worked with a four stitch edge pattern along both sides, two stitches each of both colours. When I completed the rug by knitting on the borders, I found the edge patterns to be unnecessary to the design and suggest that you leave them out. The instructions include the edge pattern in order to correspond with the illustration.

2. You will see from a quick look at the graph that the patterns are very basic, and that it would be quite simple to make the rug to any length by repeating patterns or by designing your own. If you choose to make a longer rug, then I would advise that you work the rug in knit stitch only, *not* purl back as the instructions require. Over a longer rug, the purling becomes tedious as the counting needs to be exact, whereas working in knit stitch only allows you to see the pattern throughout. This would give you a fringe along both sides thus omitting the border. A hem at the beginning and end of the rug would need to be knitted.

Harlequin can indulge all your colour fantasies with its array of simple patterns.

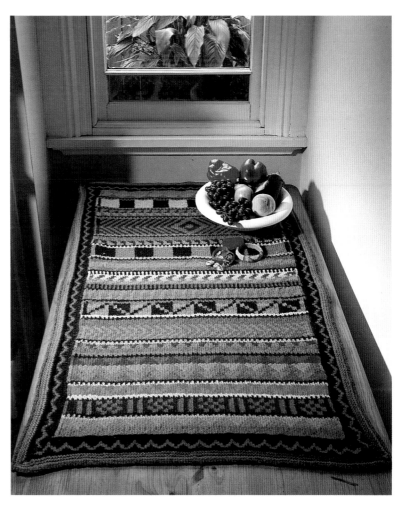

*Harlequin graph and
colour code.*

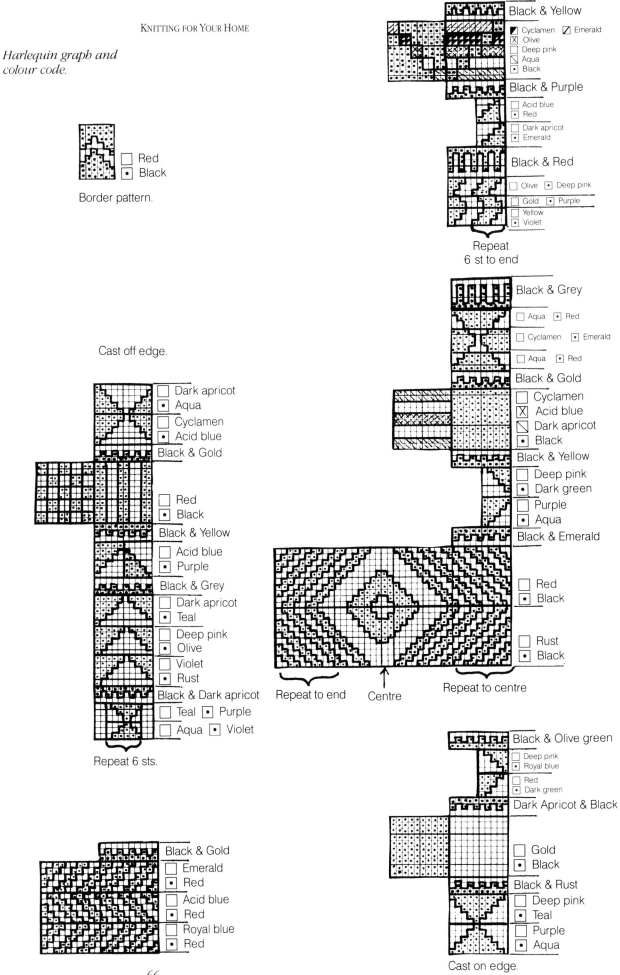

	Red
•	Black

Border pattern.

Black & Yellow

◤	Cyclamen	◩	Emerald
☒	Olive		
	Deep pink		
◺	Aqua		
•	Black		

Black & Purple

	Acid blue
•	Red
	Dark apricot
•	Emerald

Black & Red

	Olive	•	Deep pink
	Gold	•	Purple
	Yellow		
•	Violet		

Repeat
6 st to end

Black & Grey

	Aqua	•	Red
	Cyclamen	•	Emerald
	Aqua	•	Red

Black & Gold

	Cyclamen
☒	Acid blue
◺	Dark apricot
•	Black

Black & Yellow

	Deep pink
•	Dark green
	Purple
•	Aqua

Black & Emerald

	Red
•	Black

	Rust
•	Black

Repeat to end Centre Repeat to centre

Cast off edge.

	Dark apricot
•	Aqua
	Cyclamen
•	Acid blue

Black & Gold

	Red
•	Black

Black & Yellow

	Acid blue
•	Purple

Black & Grey

	Dark apricot
•	Teal
	Deep pink
•	Olive
	Violet
•	Rust

Black & Dark apricot

	Teal	•	Purple
	Aqua	•	Violet

Repeat 6 sts.

Black & Olive green

	Deep pink
•	Royal blue
	Red
•	Dark green

Dark Apricot & Black

	Gold
•	Black

Black & Rust

	Deep pink
•	Teal
	Purple
•	Aqua

Cast on edge.
Begin here.

Black & Gold

	Emerald
•	Red
	Acid blue
•	Red
	Royal blue
•	Red

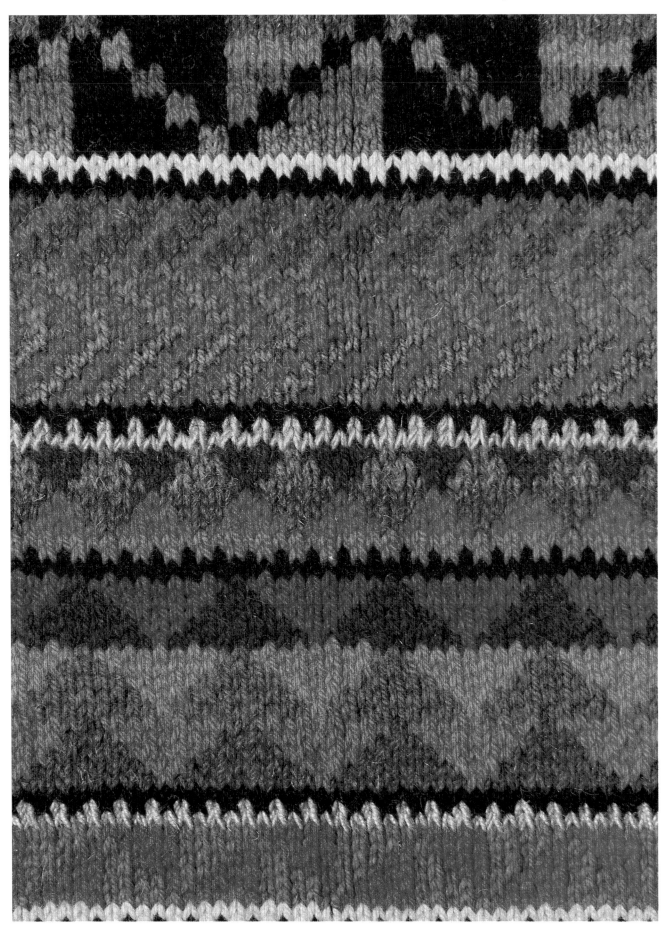

3. The patterns will fit into multiples of 20 sts, so the rug may be made wider if you choose.
4. Any one of the patterns repeated would be most suitable for smaller pieces such as mats, cushion covers or upholstery pieces.

The Rug

With 4.00 mm circular needle and aqua, cast on 108 sts.
The first and last 4 sts. of every row are edge patterns and are worked as 2 sts. main colour, 2 sts. contrast colour. (See Note 1.)
Work in rows of K. and P. (stocking st), weaving in all strands at the back.
Work from graph, maintaining the 4 st. edge pattern all the way.
Cast off.

BLOCKING

Weave in loose ends.
Thoroughly wet piece, stretch to shape and allow to dry flat.

Borders:

With black and 4.00 mm circular needle and right side facing, beg at cast on edge and pick up 102 sts. evenly.
Work from border pattern graph and at the same time inc 1 st. at both ends of every row. Include extra sts. into pattern.
Work 9 rows of patt.
Row 10: Inc in first st, K to last st, inc in last st.
Continue to inc. in first and last sts. as before along every row, but work in garter st. (every row K.) thus:
rows emerald
2 rows purple
2 rows teal
Cast off in teal.
Repeat border along cast off edge.

Sides:

With black and 4.00 mm circular needles and right side facing, pick up 114 sts. evenly on to 2 needles. Knit with the 3rd needle.
Complete border as above.

TO FINISH

Weave in loose ends.
Flat sew mitre corners together.
Press borders with damp cloth.

Chevron

Knitted by Olive Threlfall

This pattern can be used for any ply yarn working to the tension and needles recommended for that particular yarn.

You can also use this pattern to experiment with a lot of different colourways, not necessarily restricting your design to 3 colours. It is a great way to use up the odd bits of colours that we knitters seem to accumulate.

One whole chevron takes 40 sts. and measures 22 cm in width. Thus, as long as you cast on in multiples of 40 sts., you can vary the width of the rug.

You can also vary the size of the chevron by changing the number of knit stitches between the decreases and increases; i.e. instead of K.17, you could K.7 or K.12 thus making one whole chevron 20 sts. or 30 sts.

MEASUREMENTS

215 cm x 215 cm approx.

MATERIALS

Cleckheaton Mohair Classique, 50 g balls
8 balls royal blue
7 balls navy blue
6 balls pale blue
These quantities are only approximate and may vary between knitters.
1 circular 5.5 mm needle, 80 cm long.

TENSION

17 sts. and 22 rows to 10 cm over stocking st. using 5.5 mm needles or whichever will give the correct tension.

The Bed Cover

With 5.5 mm circular needle, cast on 320 sts. in navy blue
Row 1: *K.2tog, K.17, inc. in next 2 sts, K.17, SL1, K.1, psso; rep from * to end.

Note:

To assist in counting each chevron, tie a coloured yarn marker at every decrease and increase point.
Row 2: Purl.
These two rows form the patt. Repeat as necessary following the colour sequence.
navy 4 rows
royal 6 rows
pale 10 rows
royal 2 rows
navy 4 rows
pale 2 rows
navy 4 rows
royal 4 rows
Cont. patt. and colour sequence until work measures 210 cm approx. (or length desired) ending with a complete colour sequence.
Work 4 rows patt. in navy.
Cast off loosely.

TO COMPLETE

Weave in any loose ends.

The chevron pattern, using mohair, makes this the softest of the rugs to snuggle into for a nap. The pattern is so versatile that any yarn and any combination of colour can be used. If you have lots of colours to use up, every row could be a different colour with the bonus of a fringe at the edges.

Clouds of Colour

Knitted by Liz Gemmell

This throwover is ablaze with colour. Drape it over a lounge, chair or bed to create a dramatic effect. The graph adapts easily to garment designs and it requires only small quantities of yarns.

COMBINING WOVEN FAIR ISLE AND PICTURE KNITTING:

Clouds of Colour is worked with 3.75 mm needles to prevent the outline colour from showing through on the right side when using the woven Fair Isle method.

The section on woven Fair Isle gives all the details for working the knit rows, but to facilitate a faster pace, weave in the dark colour along purl rows every 3rd stitch instead of every stitch as along the knit rows.

The colour sections are worked in picture knitting i.e. adjacent colours are twisted around each other, while the dark colour is simply worked across the rows. Short lengths of colour are used allowing for better blending of shades. Use random lengths from 50 cm to 200 cm. Try to vary the lengths of adjacent colours so that the shades of colour are staggered.

A whole ball of dark colour can be used for several rows at a time. This method of short lengths of colour avoids tangles, especially when long-haired yarns are used, and it is a particularly easy method to work with.

TECHNIQUES

When joining on new colours, tie a reef knot leaving a 5 cm tail of each colour. Weave both tails in as you knit.

The more variety in textures and colour tones, the better.

Any discrepancy in ply becomes assimilated when working woven Fair Isle, so you can be quite adventurous in your choice of yarns and ply.

COLOUR

Experiment with the colour too. The more colour and shades of the colour you use, the more interest you create in the work. Dye lots cease to be a problem for this item, as more variation in shades will create a more effective end result.

Check the colour progress of your work often by holding it up to a mirror. The mirrored image gives you a fresh view of the colour placement. Also, whenever possible, leave your work displayed, as the more you look at it, the more ideas on colour placing and blending will occur to you.

MEASUREMENTS

150 cm x 182 cm approx.

MATERIALS

8 ply yarns or similar.
Main colour for border and outline.
300 g balls — navy blues, blacks, browns, dark greys
Contrast colour groups:
100 g golds: beige to biscuit
180 g reds: maroons and scarlet to bright reds
150 g blues: royal blues, jacaranda to sky blue
180 g apricots: deep cinnamon to lightest apricot
160 g oranges: browns and rusts to orange
180 g pinks: baby pinks to deep pinks and fuschia
160 g purples: violets, purples to cerise
150 g greens: bottle greens and teal to nile and apple
160 g olives: khaki and olive to lemon yellow
180 g greys: steel grey, indigo to light grey (not 'college' greys)
These quantities are approximate and may vary between individual knitters.
1 circular 3.75 mm needle, 80 cm long.

TENSION

25 sts. and 26 rows to 10 cm over woven Fair Isle pattern using 3.75 mm needles (or whichever needles needed to produce a soft fabric).

Opposite page:
Clouds of Colour makes an ideal throwover for a lounge or bed. For the knitter, its charm lies in the fact that practically any type of yarn may be used in small quantities while it dazzles the viewer with its colour and seeming intricacy.

Notes:

1. I began the throwover with an edge of 6 st. x 6 row checkerboard pattern with the CC worked in reverse stocking st. As the work progressed I found it easier to work a 2 st. x 2 row checkerboard pattern which produced a better effect. Hence the photograph shows the cover with the larger edge pattern turning into the smaller pattern. The instructions are for the smaller, easier pattern.

2. The checkerboard patterns along the bottom, top and side edges have a separate colour scheme to the main pattern. Use short lengths of CC and grade the colours from pinks to purples to violets to blues to greens and so on.

Repeat rows 1-4 twice more, 12 rows altogether.

Row 13: *K.2 CC, K.MC; rep. from * twice more, K.320 MC, *K.2 CC, K.2 MC; rep. from * twice more.

This establishes the bottom border. Work 5 more rows keeping checkerboard pattern to first and last 12 sts. and centre sts. in MC.

Row 19: K.12 checkerboard pattern, K.6 MC, rep. main graph 14 times (308 sts) tying in new CC as needed and taking MC right across row to last 12 sts, K.12 checkerboard patt.

Continue in this way until main graph has been repeated 14 times (or to the length desired).

Work 6 rows border and 12 rows checkerboard pattern as for beginning. Cast off loosely.

The Throwover

With a 4.00 mm circular needle and MC, cast on 344 sts.

Row 1: Tie in CC. *K.2 CC, K.2 MC; rep from * to end.

Row 2: *P.2 MC, K.2 CC; rep. from * to end.

Row 3: *K.2 MC, K.2 CC; rep. from * to end.

Row 4: *K.2 CC, P.2 MC; rep. from * to end.

These rows form the checkerboard pattern.

TO COMPLETE

Weave in any loose ends with a crochet hook. Press edges using a damp cloth. Pressing the whole piece will even out all the various textures of the different yarns; I prefer to retain the 'uneven' look of the textures as it gives the work a fuller appearance, so I only pressed the edges to make them lie flat.

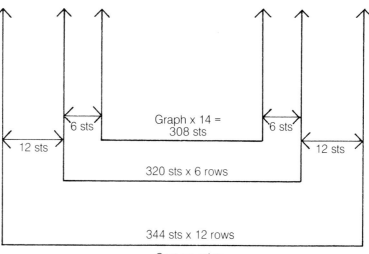

6 sts

Graph x 14 = 308 sts

6 sts

12 sts

12 sts

320 sts x 6 rows

344 sts x 12 rows

Cast on edge

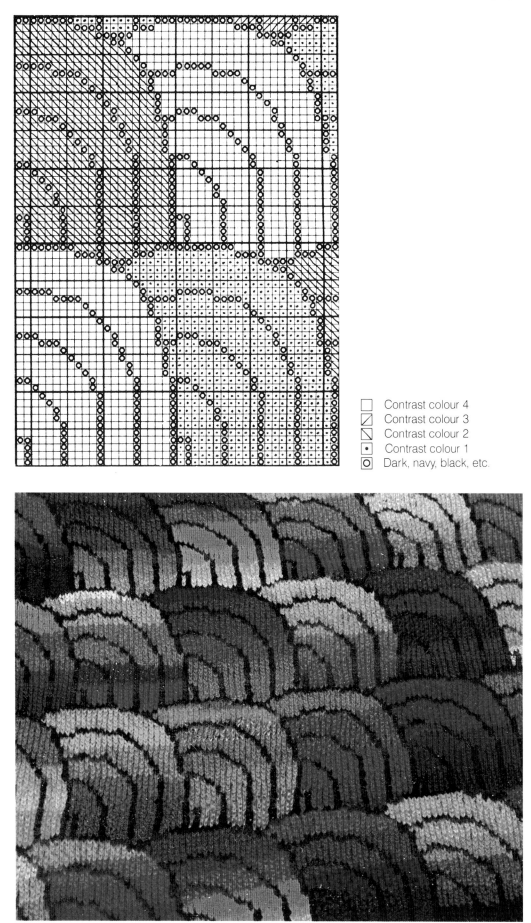

Contrast colour 4
Contrast colour 3
Contrast colour 2
Contrast colour 1
Dark, navy, black, etc.

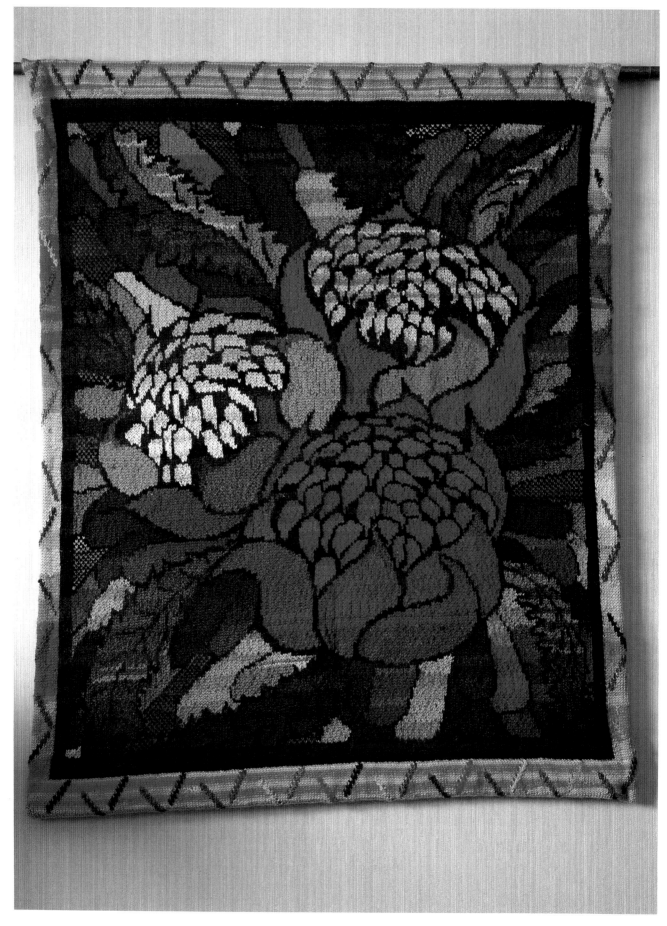

Waratah

Knitted by Liz Gemmell

A dramatic wall hanging to complement the *Clouds of Colour* throwover or to make its own statement on your wall. The waratahs have a background of tangled leaves in deep, bright colour.

COMBINING WOVEN FAIR ISLE AND PICTURE KNITTING:

The Waratah is worked on 3.75 mm needles.

The section on woven Fair Isle gives all the details for working the knit rows, but to facilitate a faster pace, weave in the dark colour along purl rows every 3rd stitch instead of every stitch as along the knit rows. The colour sections are worked in picture knitting, i.e. adjacent colours are twisted around each other, while the dark colour is simply worked across the rows. Short lengths of colour are used allowing for better blending of shades.

Use short lengths when grading the colours. Use long lengths when a whole petal or section is to be all one colour.

A whole ball of dark colour can be used for several rows at a time. This method of short lengths of colour avoids tangles, especially when long-haired yarns are used, and it is a particularly easy method to work with.

TECHNIQUES

When joining on new colours, tie a reef knot leaving a 5 cm tail of each colour. Weave both tails in as you knit.

I do not recommend using novelty yarns (such as boucles, tweeds or silks) but suggest you keep to smooth spun wools, brushed wools and mohairs.

Check the colour progress of your work often by holding it up to a mirror. The mirrored image gives you a fresh view of the colour placement. Also, whenever possible, leave your work displayed, as the more you look at it, the more ideas on colour placing and blending will occur to you.

MEASUREMENTS

100 cm x 100 cm

MATERIALS

8 ply yarns, 50 g balls
Outline and Border Colours:
6 balls navy blues, blacks, indigo
Contrast Colours, approx 1/2 ball quantities
6 pinks: cyclamen, hot pink, deep pink, bright pink, baby pink, pale pink
7 rusts: deep rust, rust, cinnamon, apricot, pale apricot, dusty pink, salmon pink
6 reds: claret, deep red, rusty red, scarlet, red, bright red
5 forest greens: teal, emerald, bright green, dark green, bottle green
6 olive greens: dark olive, khaki, light olive, golden olive, gold
2 tans: biscuit, honey
1 aqua
5 blues: violet, royal blue, bright blue, purple, jacaranda
3 dark maroons
1 circular 3.75 mm needle, 80 cm long.
1 decorative curtain rod, 120 cm long.
2 dowels 100 cm x 0.5 cm diameter.
1 slat 100 cm x 2.5 cm.

Note about colours:

The names in each colour group are to simply indicate that a large variety of shades were used. Collect as many shades of each colour group as you can. The more shades you have, the richer and livelier your work will be.

TENSION

26 sts. and 28 rows to 10 cm over woven Fair Isle pattern using 3.75 mm needles.

The Wall Hanging

With 3.75 mm circular needle and pale pink, cast on 220 sts. Work 20 rows stocking st. This will be the bottom hem.
Cast on 6 sts. at beg. of next 2 rows — 232 sts. These sts. will be the side hems.
At the same time work graph of frame pattern.

Opposite page:
A wall hanging of waratahs to complement Clouds of Colour. The dark outlines give the colours a stained glass glow.

Frame pattern.

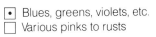
- • Blues, greens, violets, etc.
- ☐ Various pinks to rusts

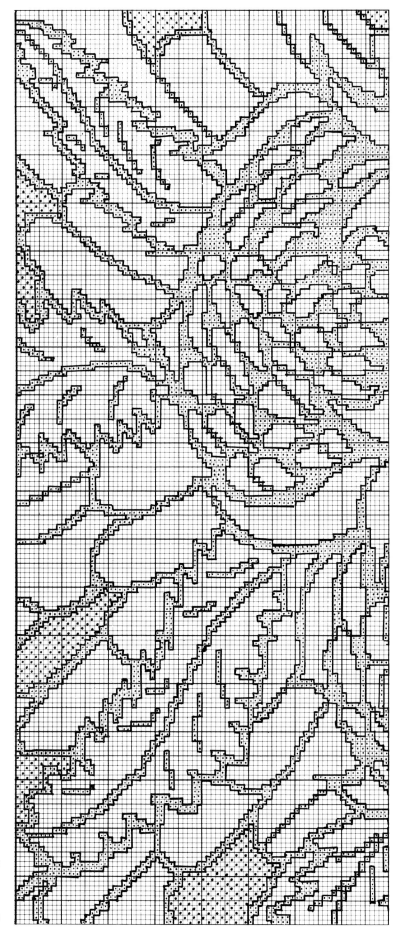

*Graph for Waratah
wall-hanging.*

- • Dark colours — navy, black, indigo
- ☐ Contrast colours — refer to colour plan

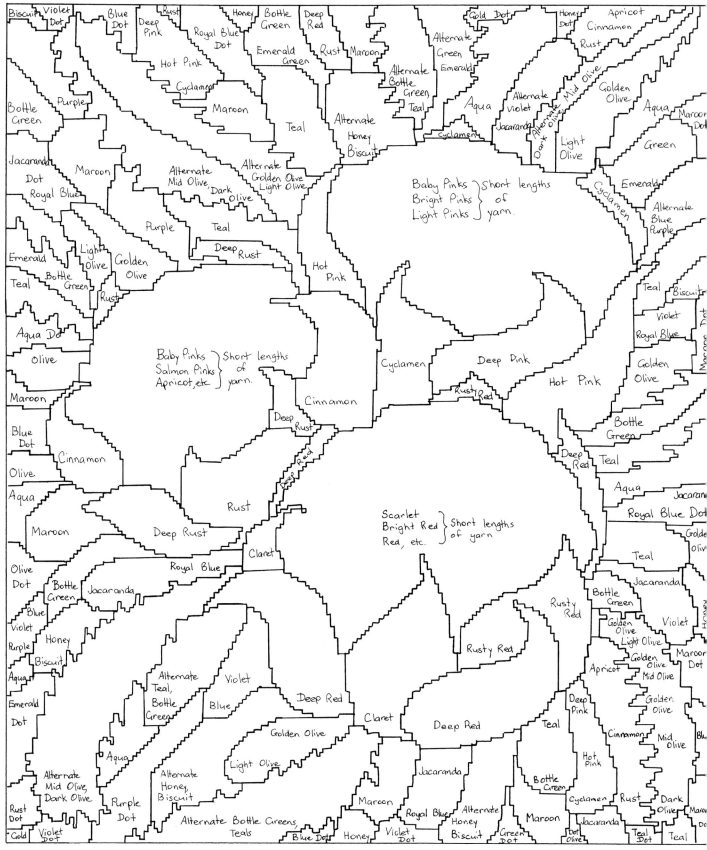

Assembly and colour plan.

Frame pattern:

Diagonal stripe colours are the blues, greens, etc. with occasional reds and golds. Each diagonal stripe is a separate thread approx 70 cm in length. Stripes may also be of 2 or 3 colours as desired. Twist this thread with the ongoing pink. Do not strand across the back. Change pinks often, varying lengths. Weave in all knots as you work.

After 20 rows, work border thus:

K.6, K.10 frame patt., tie in border colour and K.200, K.10 frame patt., K.6.

Continue in this way until 9 more rows have been worked.

Next row: K.6, K.10 frame patt., K.5 border, begin working from graph for 190 sts. using border colour to form outlines and tying in new colours as needed, K.5 border, K.10 frame patt., K.6. Refer to graph for placement of colours.

Cont. as established, twisting frame colour around the 2 colours (dark and contrast) of waratah graph at both ends of borders. Twist contrast colours around each other at colour changes. Dark colour is worked right across design inside pink frame.

On completion of waratah graph, work border and frame patt. to match the beginning. On completion of frame patt., change to a different pink and cast off 6 sts. at beg. of next 2 rows. Work 18 rows more. Cast off loosely.

BLOCKING

Weave in any loose ends with a crochet hook.

Wet thoroughly and pull gently in both directions, flatten to shape and allow to dry flat.

FINISHING

Slip stitch side hems, leaving top of hem open and stitching bottom of hem closed.

Slip stitch top and bottom hems, leaving sides open.

Check lengths of dowels and slat, adjust if necessary.

Insert dowels into side hems, slat into bottom hem and curtain rod into top hem.

Terra Australis

Knitted by Liz Post and Margaret Bell

This is one of my favourite pieces. I loved choosing all the combinations of colours and patterns to get a rich, soft, earthy effect. The yarns are a mixture of pure wool rug yarns and two strands of garment wools — 12 and 8 ply or two 8 plies together. To get the range of subtle colours in the light range, I used white with a range of pale pastels — pinks, blues, greens and greys. Most of these combinations were made up of garment yarns.

If you follow the hints on graph reading, the graph will be much easier to handle. The only sections that need concentration are the circles and waves as all the other patterns are small and predictable and need very little counting.

The fringe is multi-knotted to reduce its bulk and give it a more primitive look.

MEASUREMENTS

96 cm x 165 cm including fringe
72 cm wide without fringe

MATERIALS

Rug yarns. Other yarns may be substituted.
Quantities are approximate
655 g darks: navy, black, brown
1120 g lights: white, apricot, grey, beige, pale blue, pale pink, pale green
205 g reds: rusts, dark reds
270 g ochres: gold, biscuit, dark gold
125 g blues: teal, royal blue
1 circular 3.25 mm needle, 80 cm long
2 circular 4.00 mm needles, 80 cm long

TENSION

23 sts. and 23 rows to 10 cm over pattern.

The Rug

With 3.25 mm circular needle and a dark colour, cast on 140 sts. and work in rows of stocking st. for 5 cm to form a hem, ending on a K. row.
Next row: K. to form turning ridge and change to 4.00 mm circular needles. Work in K. rows only.
Begin reading from graph and, at the same time, inc. 20 sts. evenly along the first row thus: K. 3, inc. in next st, *K. 6, inc. in next st, rep. from * to last 3 sts, K. 3 — 160 sts.
Leave approx. 15 cm–20 cm at beg. and end of each row to form knots and fringe. Tie an overhand knot at beg. and end of every second row or so.
The blue and ochre wavy lines are knitted with a separate length of yarn, approx. 1 metre. These contrast yarns are not taken across the row. Sometimes they will need to be carried across the back to the correct stitch position. Weave in any strands thus formed as you knit across. Also weave in the two main colours as you work. The small patterns will not need any weaving.
Along the last row of graph dec. 20 sts. evenly thus: K. 2, K. 2 tog., *K. 6, K. 2 tog., rep. from * to last 4 sts, K. 4 — 140 sts.
Change to 3.25 mm circular needle and P. next row as a turning ridge. Cont. with a dark colour in rows of stocking st. for 5 cm.
Cast off.

TO COMPLETE

Slip stitch hems.
Check all knots. Tie as many overhand knots as fit comfortably, 2 to 4 knots.
Wet thoroughly and stretch to shape. Allow to dry flat.
Press hems using a damp cloth, if necessary, for hems to lie flat.

Opposite page:
Terra Australis would be equally at home on the wall as it is on this hall floor.

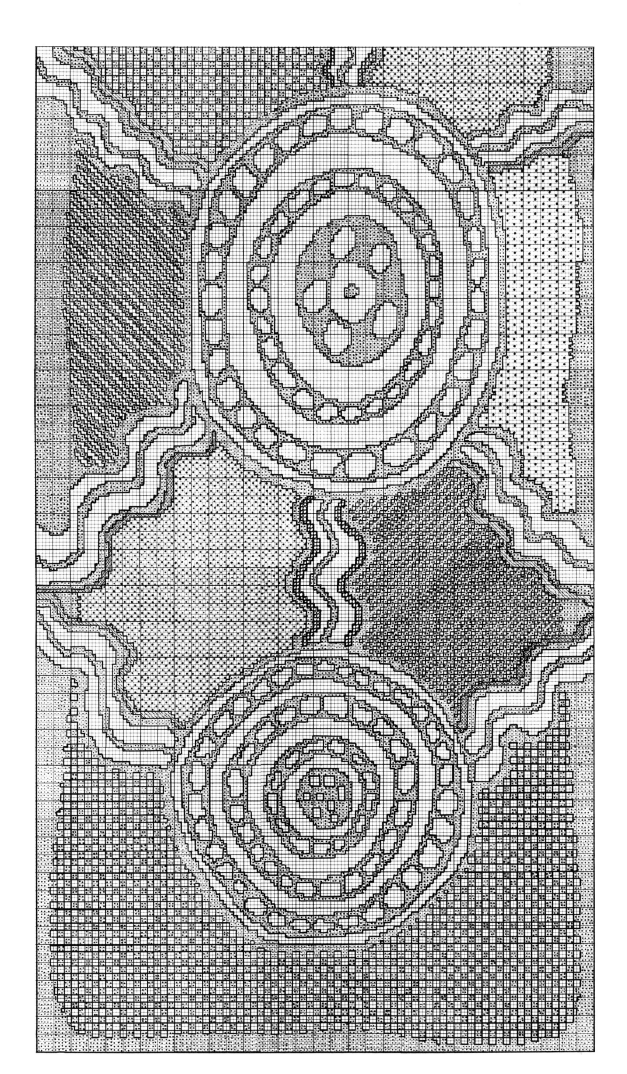

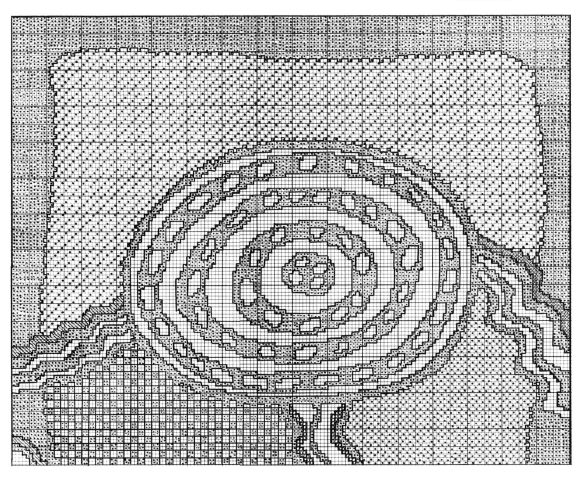

☐ Light colours
• Dark colours
◯ Gold
◲ Royal blue
☒ Teal

Note

• Dark colours are worked in a 3 row pattern:
Row 1: Black or navy
Row 2: Brown
Row 3: Red or rust etc.
After 3 or more repeats of these
3 rows, change row 3 from red to
an ochre colour, then repeat the
3 row pattern as desired.

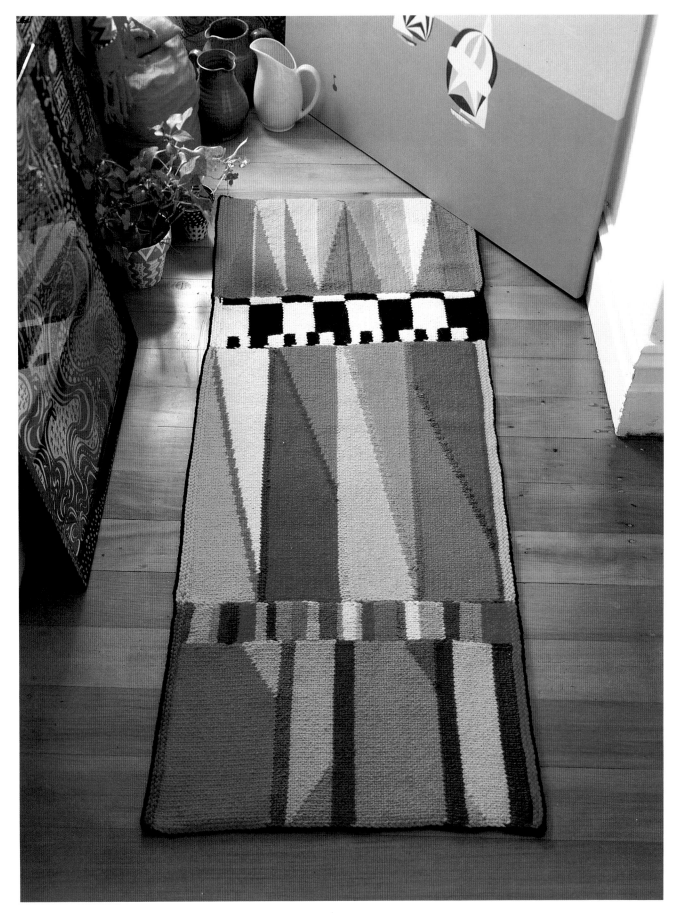

Paintbox

Knitted by Liz Post

Bold use of bright colours gives this small rug its dynamic character. Designing with these clear bright colours was sheer fun, and you get a great feeling of achievement as the knitting progresses with all the changes of colour.

The rug consists of four panels of different sizes and simple shapes. The panels are sewn together. By repeating any or all of the panels, the rug can be made to any dimension.

MEASUREMENTS

56 x 140 cm.

MATERIALS

Rug yarns. Other yarns may be substituted. Ensure all yarns are of uniform ply. Quantities are approximate.
95 g blue/green
100 g blue
65 g lemon
70 g lilac
100 g aqua
120 g orange
75 g emerald green
90 g lime green
230 g hot pink
130 g red
50 g violet
120 g yellow-gold
75 g deep yellow
40 g olive green
100 g black
100 g white
1 pair 4.5 mm needles.
(Optional 4 double pointed 4.5 mm needles.)
1 x 4.5 mm crochet hook.

TENSION

14.5 sts. and 22 rows to 10 cm over stocking stitch using double yarn.

Notes:

1. Use all yarn double.
2. Picture knitting is the method used. Twist both colours around each other at colour changes to avoid holes.
3. Slip the first stitch of every row to give a firm edge, *except* when a new colour starts at the beginning of a row. (Slipping the stitch then would bring the last colour up into the new row.)
4. Use reef knots to join all colours. Weave all knots with a crochet hook on completion of each panel. Weaving in as you knit will change the smooth appearance of the stocking stitch.

Panel A:

With 4.5 mm needles and C1, cast on 45 sts. Work 4 rows of K. before commencing to read from graph.
On completion of graph, work 4 rows of K. in last colour.
Cast off.

Panel B:

With 4.5 mm needles and C.15, cast on 20 sts. Work 4 rows of K. before commencing to read from graph. Use separate balls of C15 and C16, do not strand any colour across the back.
On completion of graph, work 4 rows of K. in last colour.
Cast off.

Panel C:

With 4.5 mm needles and C12, cast on 80 sts. It may prove easier handling to put the 80 sts. on to 3 double pointed needles and work with the 4th needle.
Work 4 rows of K. in C12 before commencing to read from graph.
On completion of graph, work 4 rows of K. in last colour.
Cast off.

Panel D:

With 4.5 mm needles and C10, cast on 50 sts. Work 4 rows of K. before commencing to read from graph. Twist colours around each other at vertical colour change to ensure a smooth appearance.
On completion of graph, work 4 rows of K. in C2.
Cast off.

Opposite page: Paintbox is knitted in four strips of varying width. Repeat the section of your choice to vary the size.

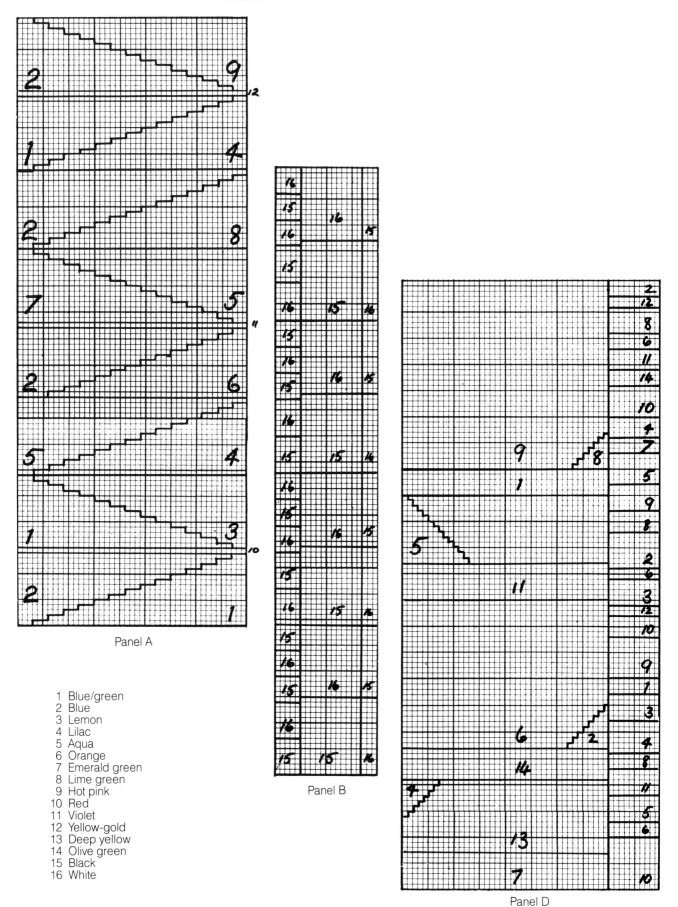

Panel A

Panel B

Panel D

1 Blue/green
2 Blue
3 Lemon
4 Lilac
5 Aqua
6 Orange
7 Emerald green
8 Lime green
9 Hot pink
10 Red
11 Violet
12 Yellow-gold
13 Deep yellow
14 Olive green
15 Black
16 White

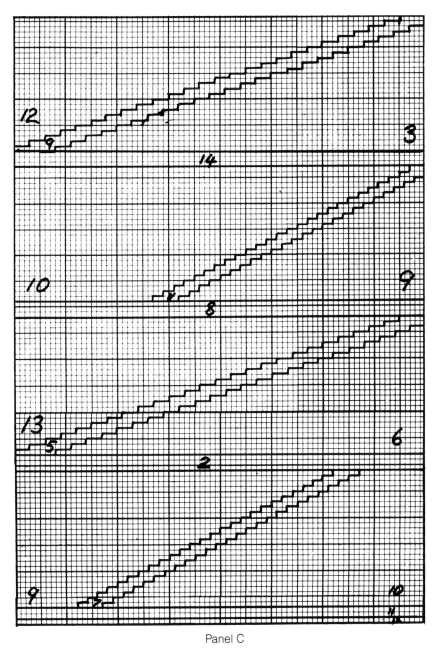

Panel C

TO MAKE UP

With a crochet hook, weave in all loose ends along colour change loops.
With right sides facing, use running seam stitch to join all panels. Follow assembly plan.

BORDER

With crochet hook and C15, work 1 round of slip stitch crochet around edges, putting 3 sts. into each corner. If desired, more rounds and other colours may be added.
Press edges using a damp cloth.

BLOCKING

Thoroughly wet piece. Stretch in both directions. Ensure it is straight.
Allow to dry flat.

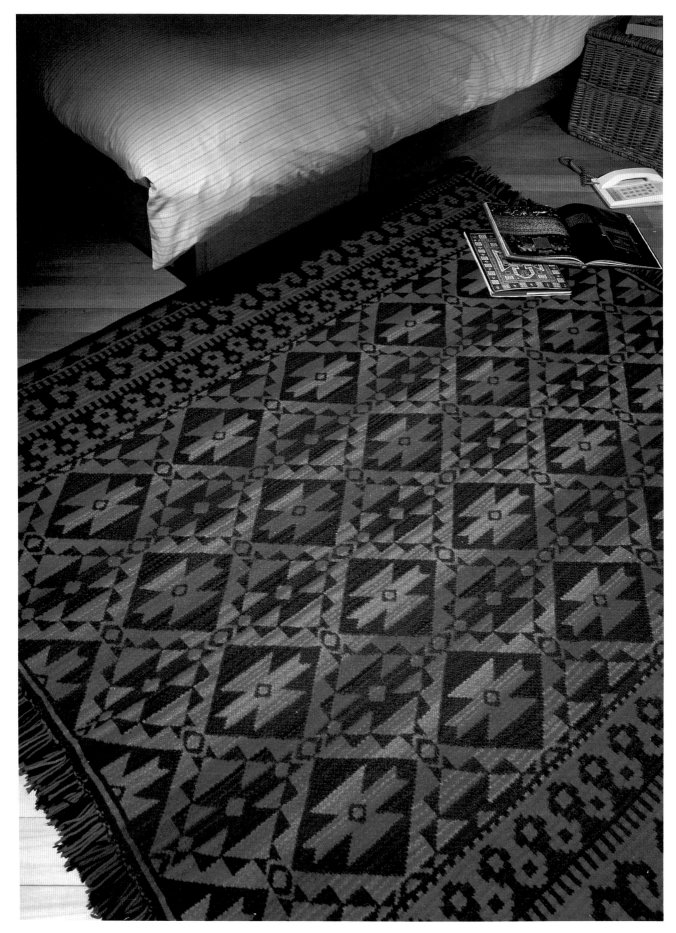

Persian Star

Knitted by Liz Gemmell

The patterns come from traditional kelims. The star, when repeated, forms an intriguing, tessellated pattern which is still simple to knit. Traditional red and navy were chosen as the colours, with all their variations in shades and tones. This is a classical rug which will become your home's focal point.

MEASUREMENTS

202 cm x 288 cm (not including fringe)

MATERIALS

Rug yarns and 12 ply and 8 ply garment yarns.
Quantities are approximate.
2000 g navy, black and dark blues
3500 g red, maroons, rusts and cerise
4 circular 4.00 mm needles, 80 cm long
3 circular 3.25 mm needles, 80 cm long

TENSION

19 sts. and 21 rows to 10 cm square over pattern using 4.00 mm needles.

Notes:

1. Every row is a different shade of navy and red.
2. Overhand knots form fringe at sides.

The Rug

With 3.25 mm circular needles and navy, cast on 372 sts. Work in st.st. (1 row K., 1 row P.) for 8 rows. Purl next row to form hem edge. Change to 4.00 mm needles and inc. along row thus: *K.14, inc in next st., rep. from * to last 12 sts., K.12 — 396 sts.
Work in K. rows only making a fringe at sides.
Work 6 rows in navies, then begin first border patt. thus: K.6 edge patt., rep. first patt. to last 6 sts., K.6 edge patt.
Keep first and last sts. as edge patt., work from graph for desired length. Rug photographed has 4 repeats of the 64 row star patt.
Turn border charts upside down and complete rug to match beginning.
Along last row of navy dec. thus: *K.14, K.2 tog., rep. from * to last 12 sts., K.12 — 372 sts.
Purl next row to form hem edge.
Change to 3.25 mm needles and work 8 rows of st.st. Cast off.

TO COMPLETE

Slip stitch hems.
Check knots along fringe and retie if necessary to readjust tension.
Wet thoroughly, block into shape and allow to dry flat. If necessary press hems using a damp cloth.

Opposite page:
Persian Star is a carpet that fills the room with warmth and colour.

Red
Navy

Casa moda

Knitted by Jean Perryman

Three basic tones strike a dramatic effect in this rug. Although it is large, the knitting is quite basic and the design is easy to follow.

It will adapt to an array of colours. Draw out a few design plans and experiment by colouring them in for yourself. Each diagonal could be a different colour. For a more subtle effect you could try using tones and shades of only two colours.

The pointed edges are an added design feature offering a break from the more usual straight lines.

MEASUREMENTS

144 cm x 310 cm

MATERIALS

Rug yarns. Other yarns may be substituted. Ensure all yarns are of uniform ply.

Quantities are approximate.
1700 g black
1680 g white
760 g grey
Small quantity of 2 contrast colours
1 pair 4.5 mm needles
1 x 4.5 mm crochet hook

TENSION

14.5 sts. and 22 rows to 10 cm over st.st. using double yarn.

Notes:

1. Use all yarn double.
2. Picture knitting is used to form the diagonal colour change. Twist both colours around each other to avoid holes in your work.
3. Two graphs are given to work the diagonal colour change rectangles. The graphs are not colour coded so that they may be

Six strips make Casa moda an easy project.

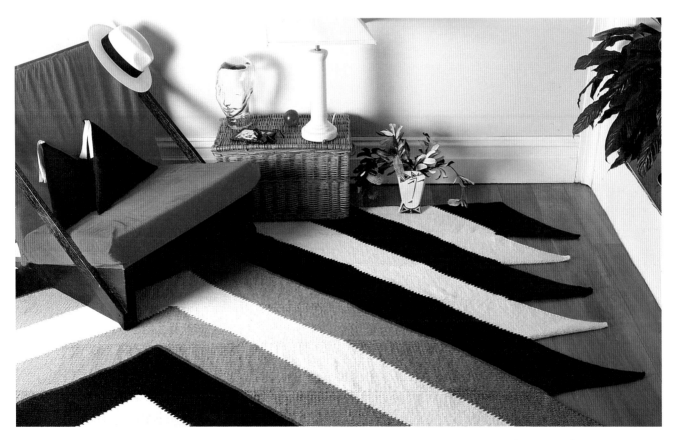

used as required for the various colour combinations.

4. Use reef knots to join all colours. Weave ends in on completion of each strip.
5. Slip the first stitch of every row to make a firm edge. Do not slip the stitch when a new colour begins a row, as this will bring the last colour up into the new row.

Strip 1:

With 4.5 mm needles and grey, cast on 2 sts.
Row 1: K.1, inc. in next st. (K. into front and back of next st.).
Row 2 and every alt. row: Sl.1 purlwise, P. to end.
Row 3: Sl.1, K.1, inc. in next st.
Row 5: Sl.1, K.2, inc. in next st.
Row 7: Sl.1, K.3, inc. in next st.
Cont. in this manner until there are 30 sts., ending on a P. row — 60 rows.
Row 61: Tie in white, K.1, K.29 grey
Row 62 and every alt. row: Sl.1 purlwise, P. sts. in colours as they occur.
Row 63: Sl.1, K.1 white, K.28 grey
Row 65: Sl.1, K.2 white, K.27 grey
Cont. in this way dec. grey by 1 st. and inc. white by 1 st. every K. row until there are 30 sts. white, ending on a P. row.
Row 121: K.1 grey, K.29 white
Row 123: Sl.1, K.1 grey, K.27 white
Cont. in this manner, remembering that after 300 rows (half-way), the colours will be brought in at the end of K. rows.
To make point at end of strip K.2 tog. at the end of every K. row. Cont. to slip first st. at beg. of every row. When 2 sts. remain, fasten off.

Weave in loose ends.

Strips 2-6:

Work in a similar manner and following colour plan, complete all strips.
Roll up each strip and label for easy storage and identification.

TO MAKE UP

With right sides facing, join all strips in order using running seam stitch. Use matching colour yarns.

BLOCKING

Thoroughly wet piece. Stretch in both directions.
Place weights on points to keep flat.
Allow to dry flat.

FINISHING

With 4.5 mm crochet hook, work 2 rows of slip stitch crochet along long sides in black. Using crochet hook and one contrast colour, work chain stitch on top of rug along grey/black line. Hold hook on top of work and yarn underneath rug. Work second colour in same way.
Press edges and points using a damp cloth.

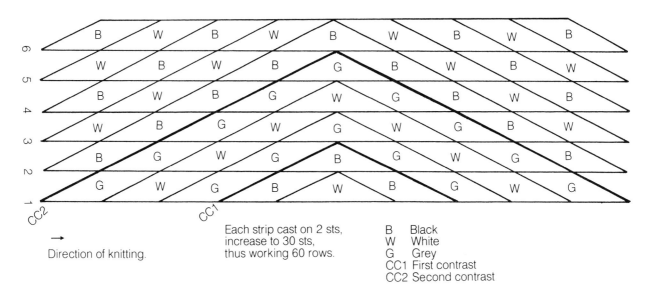

Direction of knitting.

Each strip cast on 2 sts, increase to 30 sts, thus working 60 rows.

B Black
W White
G Grey
CC1 First contrast
CC2 Second contrast

Colour plan.

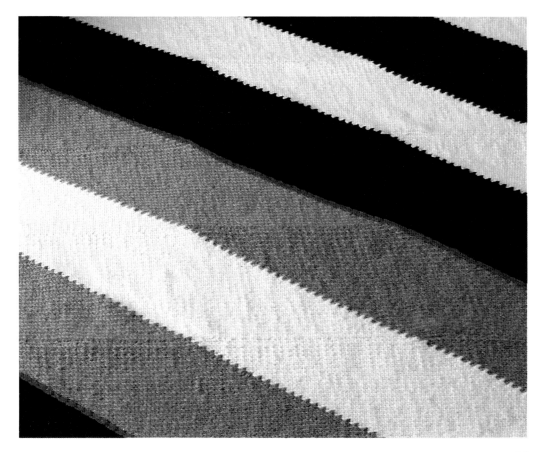

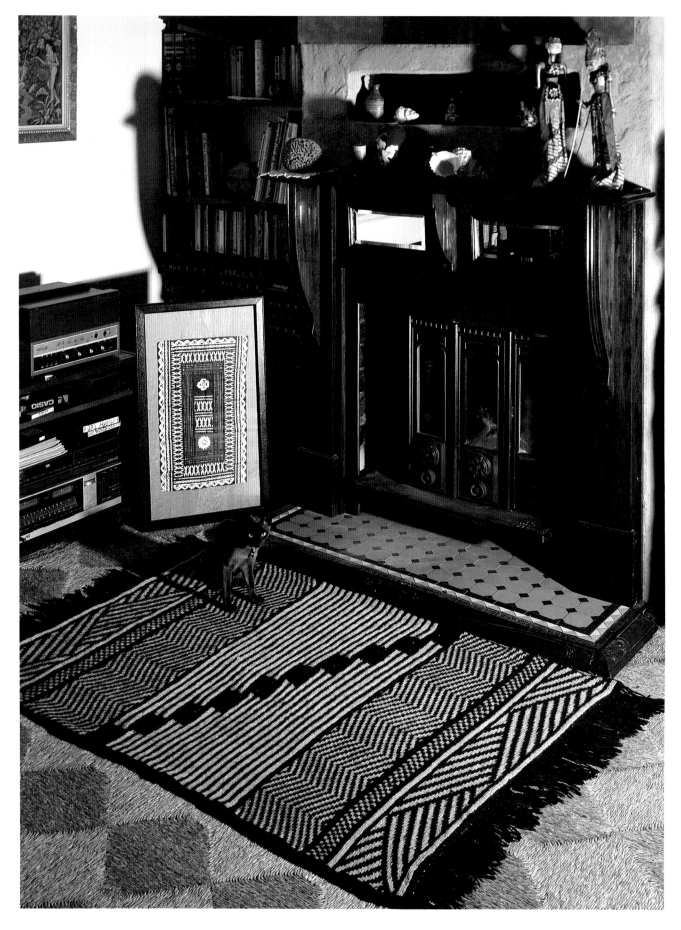

South Seas

Knitted by Jean Perryman

Very simple geometric patterns in dark contrast neutrals make a striking floor piece. The patterns are reminiscent of the bold tapa mats of the Pacific Islands.

An interesting variation would be to add more colours to the two main contrasts.

MEASUREMENTS

96 x 146 cm without fringe
96 x 166 cm with fringe.

MATERIALS

Rug yarns. Other yarns may be substituted. Quantities are approximate.
900 g stone
700 g navy
700 g brown
2 x 3.25 mm circular needles, 80 cm long
2 x 4.00 mm circular needles, 80 cm long

TENSION

22 sts. and 23 rows to 10 cm over pattern.

Notes:

1. Two identical pieces are knitted, then sewn together as shown in assembly plan.
2. Work st.st. in rows of K. and P.
3. Contrast colours, navy and brown, alternate every 2 rows.
4. Along the vertical edge, a fringe is formed with the navy and brown yarns.
5. The stone colour is continuous; it is used every row and is not cut to form the fringe.
6. Along the diagonal edge, dec. 1 st. at the end of every K. row by K.2 tog.
7. Most of the time there will be no need to weave in the strands at the back, as the pattern is small and does not go over large numbers of sts. However, occasionally, strands must be woven in when working over 4 or more stitches.

The Rug

Work 2 pieces the same.
With 3.2 mm circular needles and navy, cast on 187 sts. Work 10 rows in st.st., inc. 1 st. at end of every K. row until 192 sts.
P. next row to form turning ridge for hem.
Change to 4.00 mm circular needles and cont. in navy. Inc. 10 sts. evenly along the first row thus: K 1, inc. in next st., *K. 19, inc. in next st., rep. from * to last 10 sts., K.10.
P. next row. Cut navy at end of row, long enough to form fringe.
Rejoin navy, leaving tail to form fringe.
Dec. 1 st. at end of next and every K. row until graph complete.
Work from graph forming fringe every 2 rows with the alternating colours and dec. as stated.
On completion of graph work 3 rows navy, dec. as before.
Next row P. and dec. 10 sts. thus: *P.8, P.2 tog., rep. from * to last 2 sts., P.2 — 92 sts.
Change to 3.25 mm circular needles and P. next row to form turning ridge for hem.
Work 10 rows st.st., inc. 1 st. at end of every alt. row.
Cast off.

HEMS

Slip stitch into place, leaving 5 cm unsewn at diagonal edge.

BLOCKING

Check tension at fringe sides. Retie knots if necessary.
Weave in any loose ends.
Thoroughly wet both pieces and assemble as shown in layout. Stretch in both directions and match diagonal edges.
Allow to dry flat.

TO COMPLETE

With right sides facing and diagonal edges butted together, use running seam stitch to join pieces together.
Complete stitching hems.
Press all seams and hems using a damp cloth.

Opposite page:
South Seas is worked in two identical pieces. The graphic patterns allow for easy knitting.

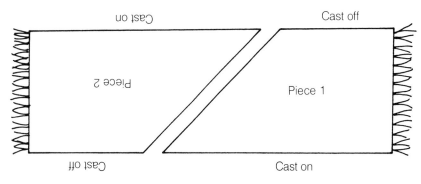

Layout.

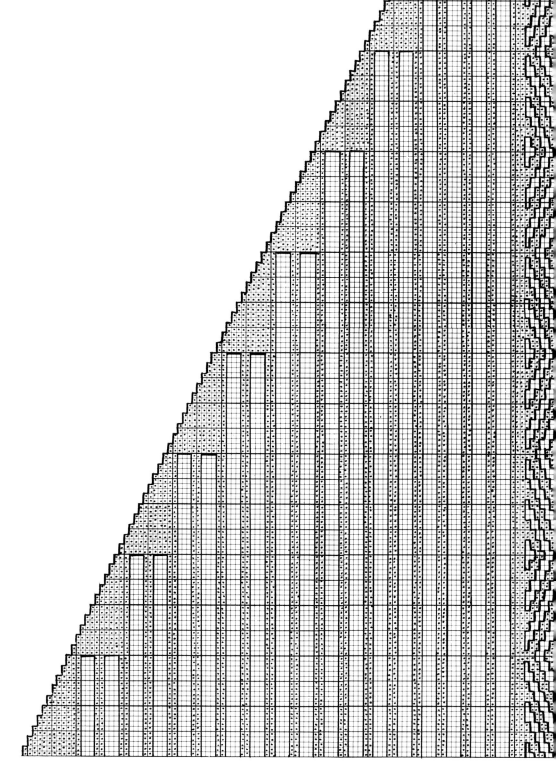

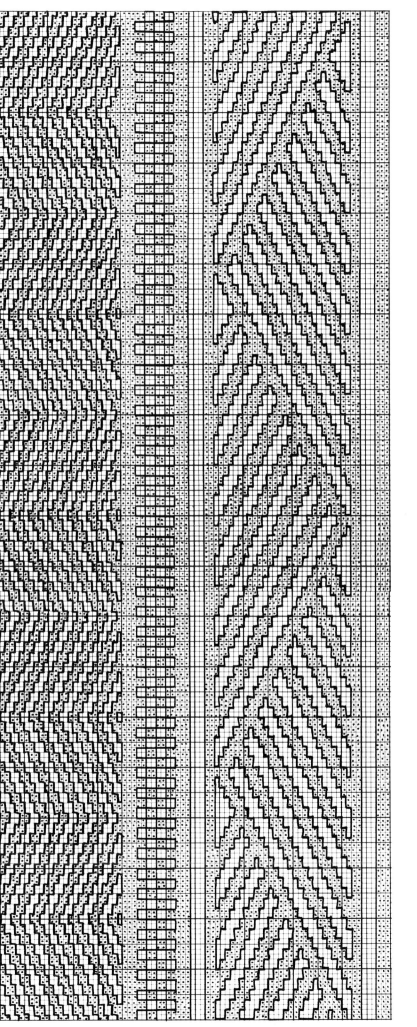

□ Stone
⊡ 2 rows of brown, then
2 rows of navy

Circular Pieces

With these two rugs or table covers, tension is critical. You must get as close as possible to the stitch and row tension. There is some tolerance in the pattern to allow the tension to be within 1 stitch and 1 row of the stated tension. If your tension is tighter than the tolerance allows, your work will dome up. When the tension is looser than stated, your work will frill and buckle.

Fortunately, the circle is such an adaptable design that both patterns can be stopped at any complete round to make a mat or cushion cover. This makes it a good way to adjust your tension first before tackling the larger project.

The circle starts off on a set of double pointed needles. As the stitches increase, one needle is used for every segment of the circle and one with which to knit. Finally, the stitches are transferred to circular needles, again one needle for each segment. If you place two segments on to a circular needle, tie coloured thread on to the needle between the segments to identify the end of one and the beginning of the next segment. Have a different coloured marker to show the beginning of the round.

I found the most awkward part to be the very beginning when I had four or so needles and very few stitches. This only lasted for a few rounds as the stitches increased to manageable numbers.

Kaleidoscope

Knitted by Margaret Bell

A circular rug with simple geometric patterns that repeat in each of the nine leaves giving the impression of a twirling kaleidoscope. The colours glow from the centre reds to the brilliant blues at the outer edge.

You think it looks rather challenging? Yes, this one does need some perseverance to complete. But there are compensations — the patterns are easy to recognise and memorise and the colour changes show you the progress of your work. Your effort will be rewarded.

MEASUREMENTS

90 cm straight edge of each leaf — radius.
180 cm diameter.

MATERIALS

Rug yarns. Other yarns may be substituted. Quantities are approximate.
90 g reds
240 g black
540 g navy
140 g bright blue
240 g royal blue
140 g grey blue
100 g tan
100 g deep tan
160 g tobacco
140 g light brown
160 g Nile green
40 g light green
180 g grey green
110 g olive green
230 g dark green
200 g light plum
220 g dark plum
130 g maroon
130 g sunset pink
10 x 4.00 mm double pointed needles.
10 x 4.00 mm circular needles, 80 cm long.

TENSION

23 sts. and 26 rows to 10 cm over pattern using 4.00 mm needles or whichever needles will give you the correct tension.

Notes:

1. The pattern can be stopped at any round, so that a round mat or cushion cover with just the red star is possible, or you can continue to create larger mats.
2. I used a variety of rug and garment wools of almost identical plies and the circle still took shape. I was concerned that the varying yarns would misbehave and not conform to a circle, but after blocking and pressing, the piece lay beautifully flat.
3. The tension is reasonably critical. I would advise working a small sample in your chosen yarns and adjust the needle size as necessary. Try to get as close as possible to the tension stated — no more than 1 st. either side of the number given. Also block your sample to confirm that you will get a flat circle.

The Circle

Follow colour changes along side of graph. The centre star is in dark red to bright red,

Centre of Kaleidoscope.

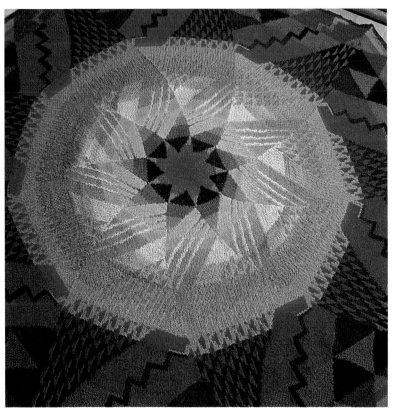

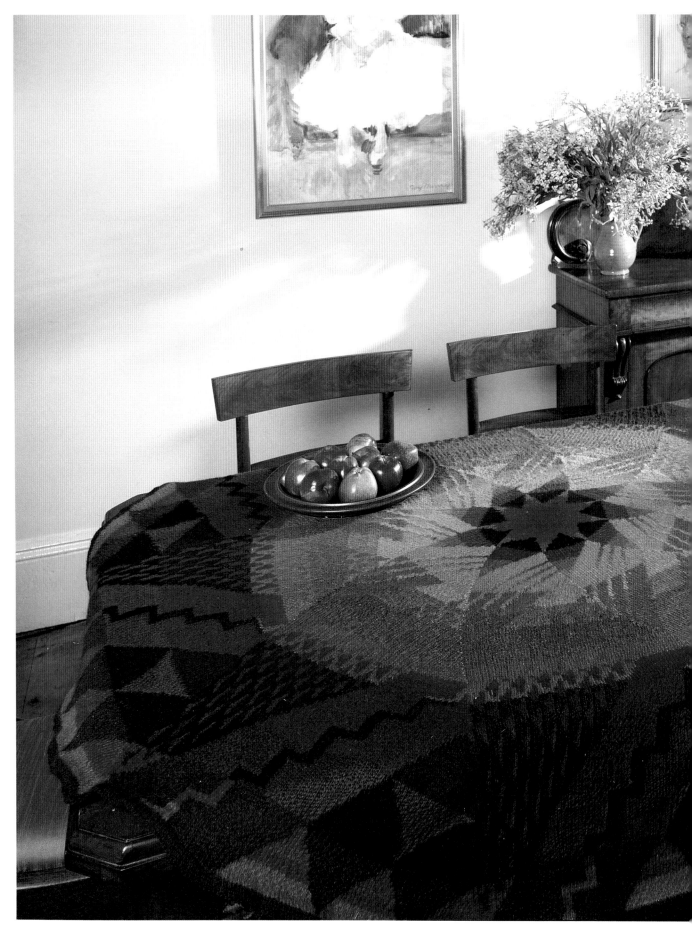

Kaleidoscope is a challenging project. With its luminous colours, the knitting and patterns are beautifully simple.

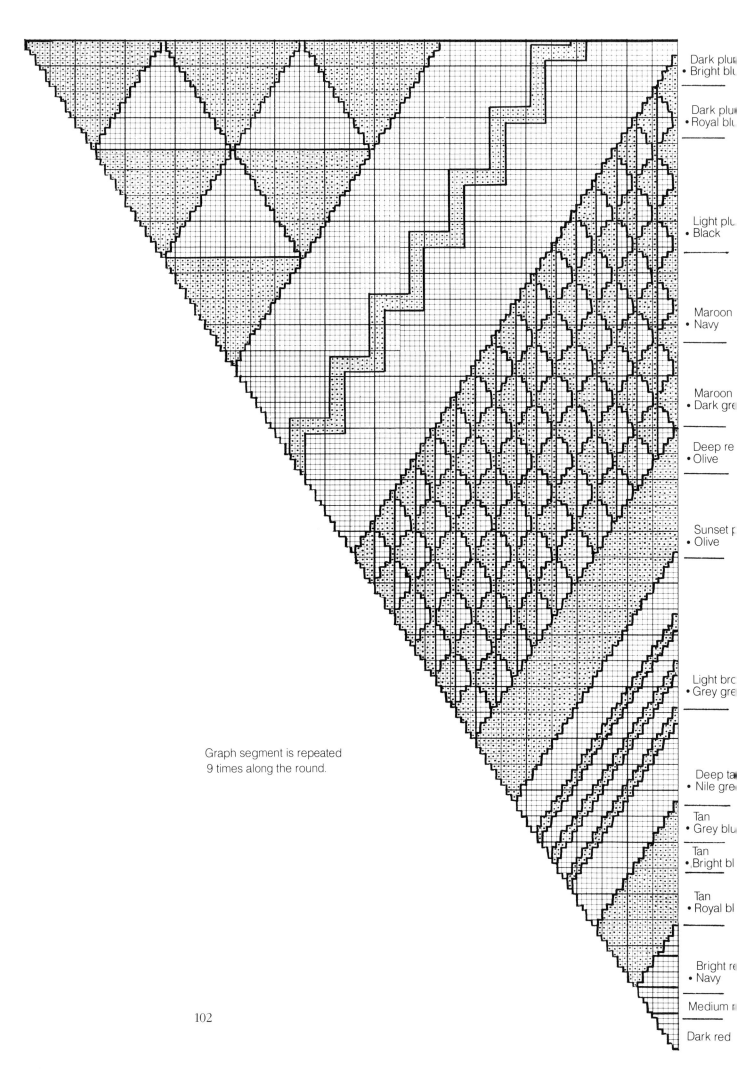

Graph segment is repeated
9 times along the round.

Dark plu▒
• Bright blu▒

Dark plu▒
• Royal blu▒

Light plu▒
• Black

Maroon
• Navy

Maroon
• Dark gre▒

Deep re▒
• Olive

Sunset ▒
• Olive

Light bro▒
• Grey gre▒

Deep ta▒
• Nile gre▒

Tan
• Grey blu▒

Tan
•‚Bright bl▒

Tan
• Royal bl▒

Bright re▒
• Navy

Medium r▒

Dark red

102

but after that, all the colours may change as you wish. The exact round to introduce a new colour is not important. In fact, try to stagger each new colour so that two new colours do not always, if at all, begin along the same round. Introduce the second new colour 5 to 15 rounds later.

Hold your work up to a mirror often. This will give you a fresh look at the progress of your colour combinations.

With 4 double pointed 4.00 mm needles and red, cast 9 sts. on to 3 needles — 3 sts. to each needle, K. with the 4th needle — this is Round 1 of the graph.

Mark end of round with coloured yarn tied onto the needle.

Round 2: Inc. in every st. — 18 sts.
Round 3: K.18.
Round 4: K.1, inc. in next st.: rep. to end.
Round 5: K.2, inc. in next st.: rep. to end.
Round 6: K.36.
Round 7: K.3, inc. in next st.: rep. top end.
Round 8: K.4, inc. in next st.; rep. to end.
Round 9: K.54.

Cont. in this way, inc. twice every 3 rows and follow suggested colour changes.

Occasionally you will need to increase a stitch and work it in a different colour at the same time. Knit into the front of the stitch with the old colour and into the back of the same stitch with the new colour.

Weave in all strands as you work.

Add extra double-pointed needles as needed until all 9 needles are used and K. with the 10th needle.

As sts. increase, change to circular needles, 3 at first and then use all 9 needles, knitting with the 10th needle.

On completion of graph (or as desired), work 1 P. row in navy to form turning ridge for hem.

With navy, cont. in rounds. Dec. 1 st. at end of every section every row for 8 rows.

Cast off.

TO COMPLETE

Weave in loose ends.
Slip stitch hem into position.

BLOCKING

Thoroughly wet piece. Work from centre to outer edge stretching piece. Stretch along beginning side of each section. Allow to dry flat. Press work using a damp cloth.

Chinese Fish

Knitted by Liz Gemmell

The combination of blues and white must be a universal favourite. I never tire of seeing blue and white Chinese vases, plates and bowls; their freshness is entrancing.

I tried to give the blues of this rug the brightness and the hand-painted look of the Chinese vases by using many shades of blue, a delightful exercise on its own.

The geometric centre would make an interesting mat. The circle can be stopped on any complete round, thus making it ideal for working smaller pieces if you are unsure of tackling the whole piece.

The fish itself was fascinating to knit. As each segment is repeated six times, familiarity gradually made the fish design easier to knit as I progressed.

A circle of leaping fish to knit in a range of blues. This rug is worked in six panels, using garment yarns.

MEASUREMENTS

Diameter 110 cm approx.

MATERIALS

12 ply yarns 50 g balls
20 balls white
20 balls blues
These quantities are only approximate and may vary for individual knitters.
7 double pointed 4.00 mm needles
7 circular 4.00 mm needles, 80 cm long.

TENSION

27 sts. and 27 rows to 10 cm square using 4.00 mm needles over pattern.
The tension is reasonably critical otherwise the circle will not be formed, so do a tension sample first in your intended yarns and adjust the needle size if necessary. Read the detailed section on woven Fair Isle.

YARNS

These are all standard 12 ply, mostly pure wool with a couple of colours from the wool blend range. I also used an 8 ply blue together with a 5 ply blue to get the required thickness of yarn and this added to the shading effect. Do not choose mohair or other fluffy yarns for the rug. Choose the blues so that the colours can range from darkest navy through the mid royal blues and end at a light blue (though not too pale). Teal and aqua tones add interest.

For the white background, I chose to use the range of whites available, from creamy naturals to dazzling white. However, this colour range is so subtle that it does not dramatically add to the colour design. Using one white would probably be just as effective. In this case, I suggest you use a creamy, natural, white, rather than a dazzling white.

The blue colours are cut off in short lengths, about 10 cm to begin with. As the circle gets bigger, use a ball of blue and change blues after every round or so. Stagger the blue changes so that they do not occur at the same place on each round. The white may be used as a complete ball and as the blues keep changing, tangling or twisting is

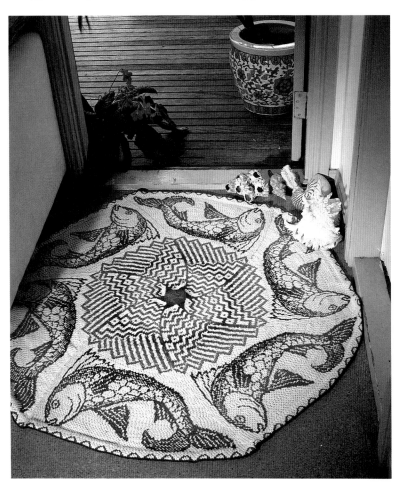

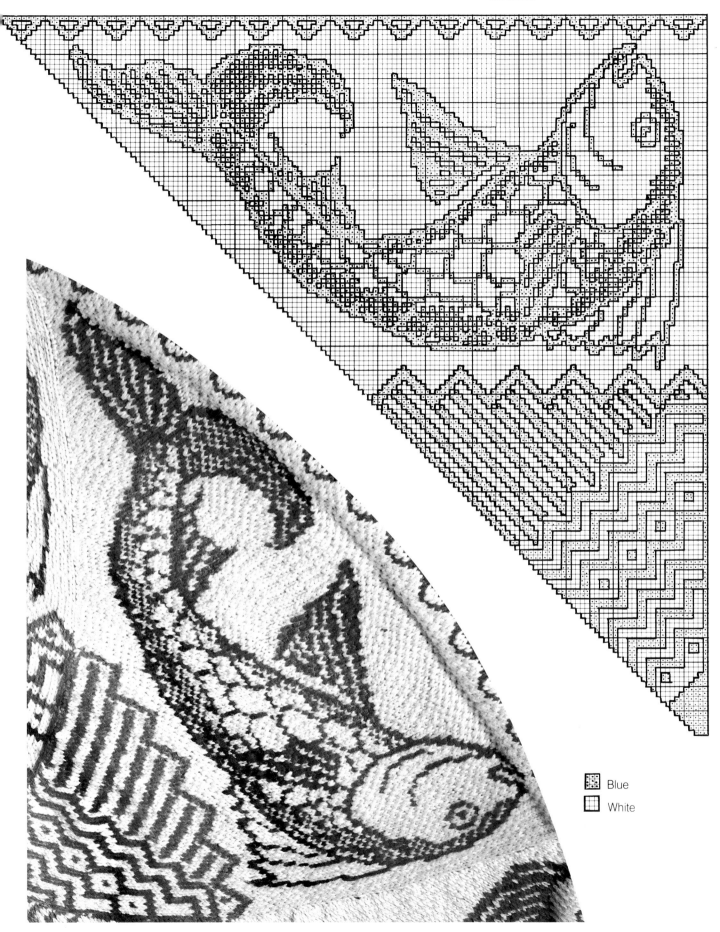

Blue

White

avoided. Tie in new colours using a reef knot, and leaving a 5 cm tail of each colour. Weave in both ends as you knit.

Notes:
1. Don't despair if the rug is appearing distorted and wavy. You will see from the photo of my unblocked rug that this is its normal state (see page 19).
2. The rug begins at the centre with the stitches on 3 double pointed needles, knitting with the 4th needle. Add the 3 extra needles as the stitches increase. Also as the stitches increase change to the circular needles. The stitches for each panel will be on one circular needle. Tie in a contrast coloured marker to show the beginning of each round.
3. The rug is made up of six triangular panels. Each panel is one repeat of the graph, thus the graph will be repeated six times to form one round.
4. The graph is read from right to left only. All increases occur at the end of each panel. Increases are made by knitting into the front and back of the last stitch of each panel. Always work the increases in the colour as indicated on the graph. Suggested blue colour changes are noted alongside the graph.

The Rug

With royal blue and 4 x 4.00 mm double pointed needles, cast on 9 sts, 3 sts. on each needle, leaving a 30 cm tail to be used to pull in the central hole on completion.
Join sts. into a circle and commence working from graph.
Add extra needles as stitches increase.
Change to circular needles as needed.
On completion of graph, work one whole round in navy and purl st. with no increases.
Now work 6 rounds in stocking st. (K. each round and dec. 1st at the end of each panel).
Cast off.

TO COMPLETE

Turn hem to wrong side and slip stitch into place.
Thread a wool needle on to the cast-on tail and work running stitches around central hole. Pull yarn to bring work together.
Oversew on wrong side and secure thread.
eave in any loose tails on wrong side.
Wet and block, following the general instructions for this process.

Banksia

Knitted by Liz Gemmell

I love the banksia for its perverseness. It's not soft or delicate, nor is it iridescently coloured, yet it's beautiful, with its honey perfume and cylindrical shape surrounded by glossy leaves that seem to have been cut from leather. Banksias grow as robust, untamed trees resisting any order that we would like to impose on them.

The Australian artist, Margaret Preston, paid homage to the banksia. Her paintings were bold and forthright and showed her familiarity and love of native flora. This was the inspiration for my rug.

MEASUREMENTS

100 cm x 127 cm approx. (not including fringe)

MATERIALS

Rug yarns and various garment yarns.
1650 g dark greens
1000 g corals, pinks and golds.
Small quantity contrast colours — violets, jades.
1 circular 3.25 mm needle, 80 cm long
3 circular 4.00 mm needles, 80 cm long.
These quantities are only approximate and may vary between individual knitters.

TENSION

20 st. and 22 rows to 10 cm square using 4.00 mm needles over pattern.

YARNS

Rug yarns are used together with garment yarns in order to get a large range of colours and shades.
The rug yarns are slightly thicker than 12 ply garment yarns, so 2 strands of garment yarns are used to match the rug yarn thickness e.g. a 12 ply with an 8 ply, or 2 x 8 ply strands. These 2 strands allow for an interesting mix of colour.

COLOUR

Background:

A mixture of dark greens is used together with some olives, browns, teals and navy blues. The latter are placed at random, so that the overall effect is dark green.

Basket and Frame:

The basket begins as pale dusty pinks and gradually shades into lilacs and mauves.

To achieve the colour gradation, repeat a colour in alternate rows, introduce a new colour and repeat this in alternate rows, then increase the rows between the original colour.

A basket of banksias in shades of apricots and pinks makes a rug for the hearth or wall.

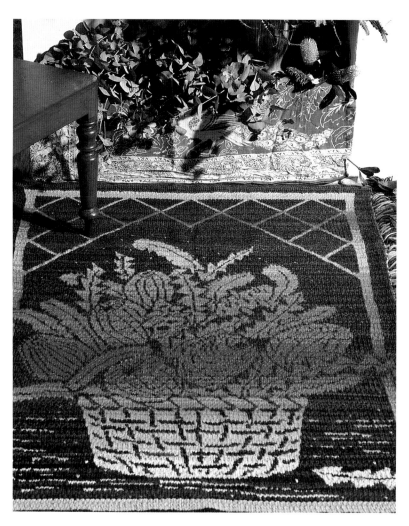

107

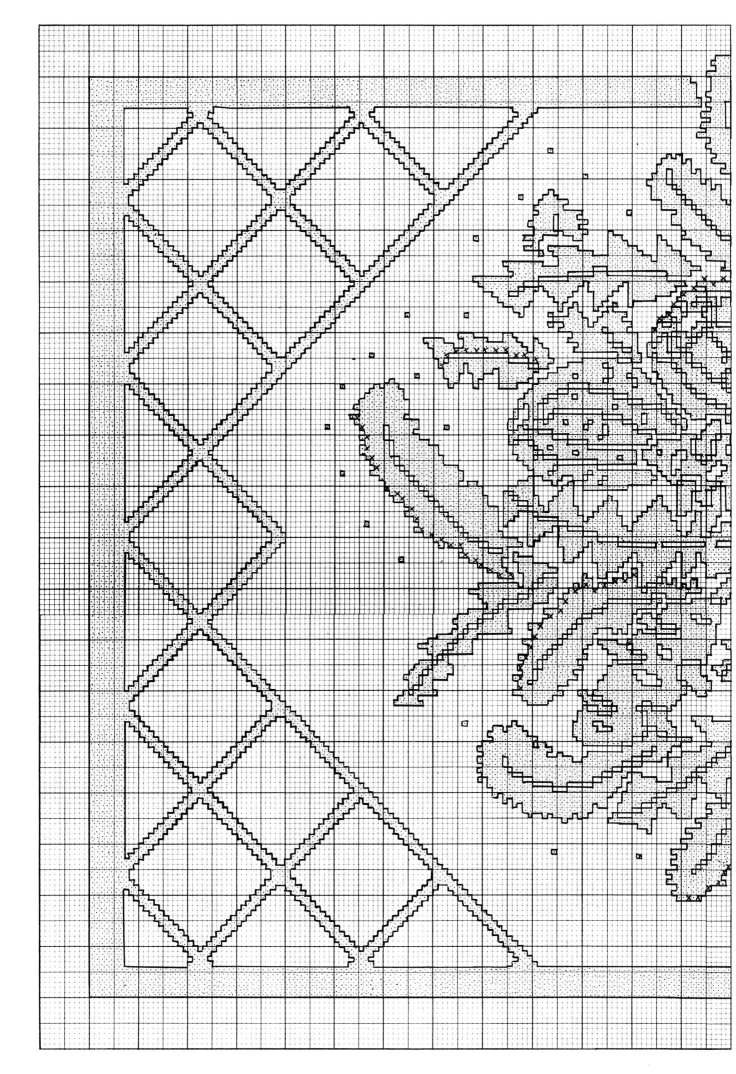

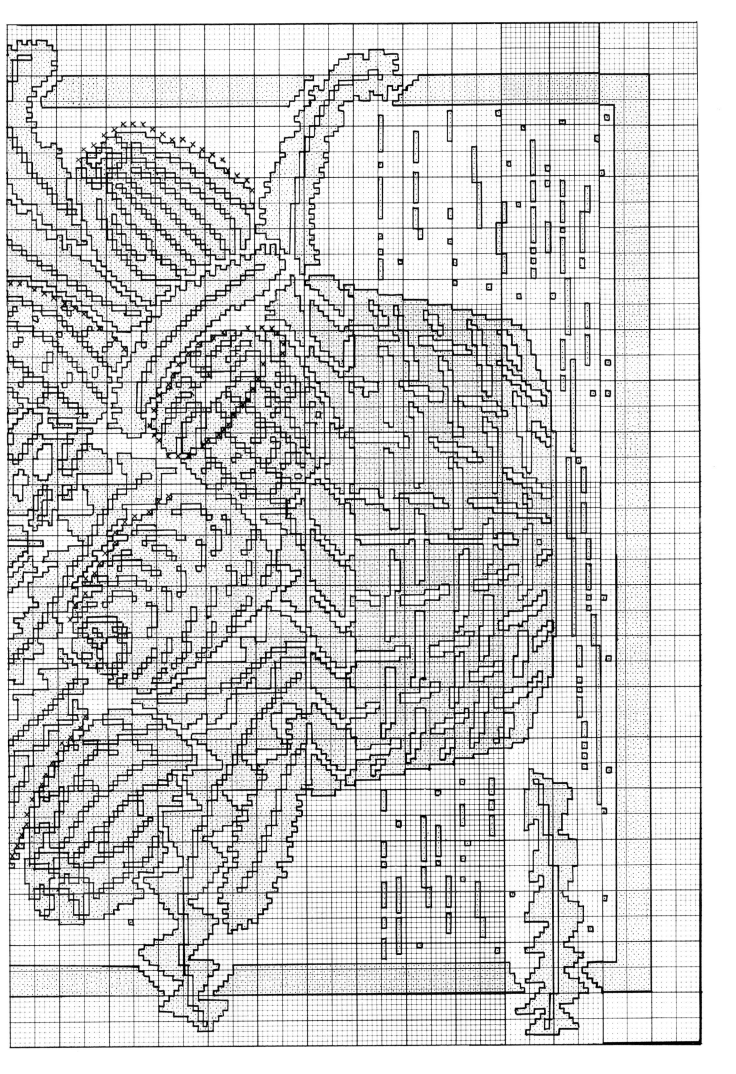

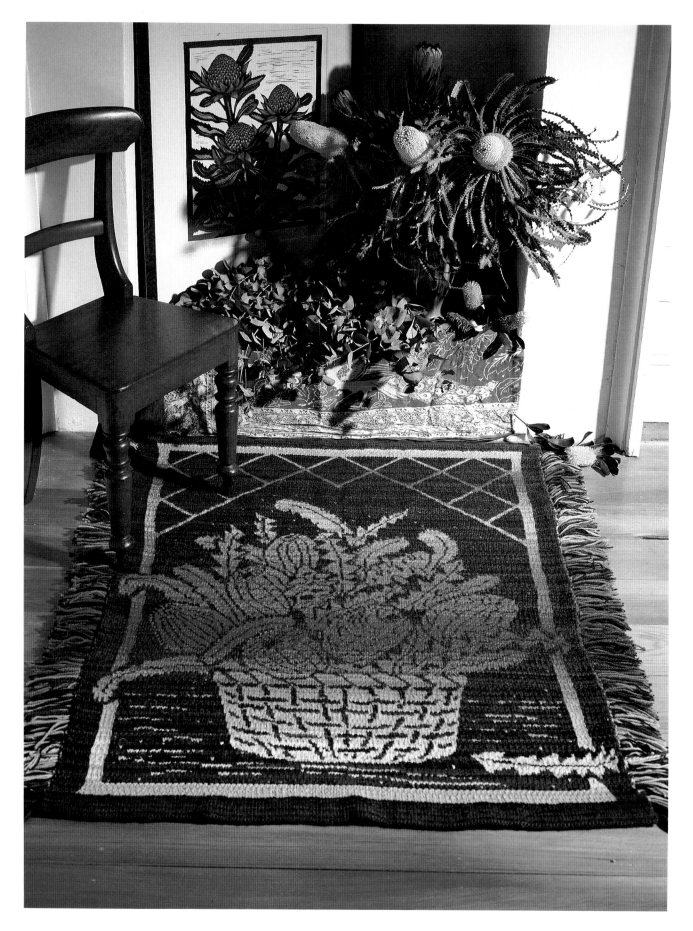

e.g. *Row 1:* dusty pink
Row 2: light pink
Row 3: dusty pink
Row 4: light pink (last row)
Row 5: dusty pink
Row 6: lilac (new colour)
Row 7: dusty pink
Row 8: lilac
Row 9: mauve (new colour)
Row 10: dusty pink (last row)
Row 11: lilac
Row 12: mauve
Row 13: pink (new colour)
Row 14: lilac
and so on.

Try not to be predictable in finishing or introducing colours; the colour gradations should not appear as stripes.

Hold your work up to a mirror frequently. This will give you a fresh, overall view of your colour progress, and will help you decide whether to extend the current shading or whether to introduce a new shade.

Flowers, Leaves and Frame:

The basket ends in corals and sunset tones and this colour deepens as the flowers and leaves begin to be worked. Try to keep the coral tones to a medium darkness, avoid maroons and deep rusts as these will be too close in tone to the background colours. Then lighten the colours to corals and oranges. The oranges should shade into gold and yellow; and the yellows into tan and pink so that the top lattice colours can become deep pinks fading into the lighter pinks of the beginning of the pattern.

Single Stitch Contrasts:

Keep contrasts dark, and choose violets, purples, teals and royal blues. These are *not* carried along the row. Tie in a length of contrast yarn and simply knit the single stitch as it occurs. There is no need to twist this thread with the 2 threads of the Fair Isle pattern. If the thread is not long enough, tie in an extra colour, not necessarily the same one.

The Rug

With circular 3.25 mm needle, using dark green, cast on 180 sts. Work in stocking st. (1 row K., 1 row P.) for 10 rows. P. next row as turning row for hem.
Change to 4.00 mm circular needle and inc. 20 sts. evenly along row thus:
K.4, inc. in next st., *K.8, inc. in next st.; rep. from * to last 4 sts, K.4 — 200 sts.
Place sts. on 2 circular needles and knit with the 3rd needle.
Follow graph, working only K, rows. Leave a 20 cm tail at each end of every row. Tie knots every 2 rows.

Knots:

Tie an overhand knot with the 4 (or more) strands of every 2 rows. This will mean that each first row will have the tails left loose until the second row has been worked. Push knot as close as possible to the fabric of the rug.
Change background and pattern colours every row.
Work in woven Fair Isle technique.
On completion of graph, reduce sts. to 180 sts. thus: K.4, K.2tog., *K.8, K.2 tog., rep from * to last 4 sts, K.4.
Work 1 P. row.
Change to 3.25 mm needles and work in stocking st. (1 row K., 1 row P.) for 10 rows. Cast off.

TO COMPLETE

Slip stitch hem into place.
Check all knots; retie if necessary.
Wet and block rug as described in general instructions.

☐ Greens
⊡ Reds
☒ Violet, navies

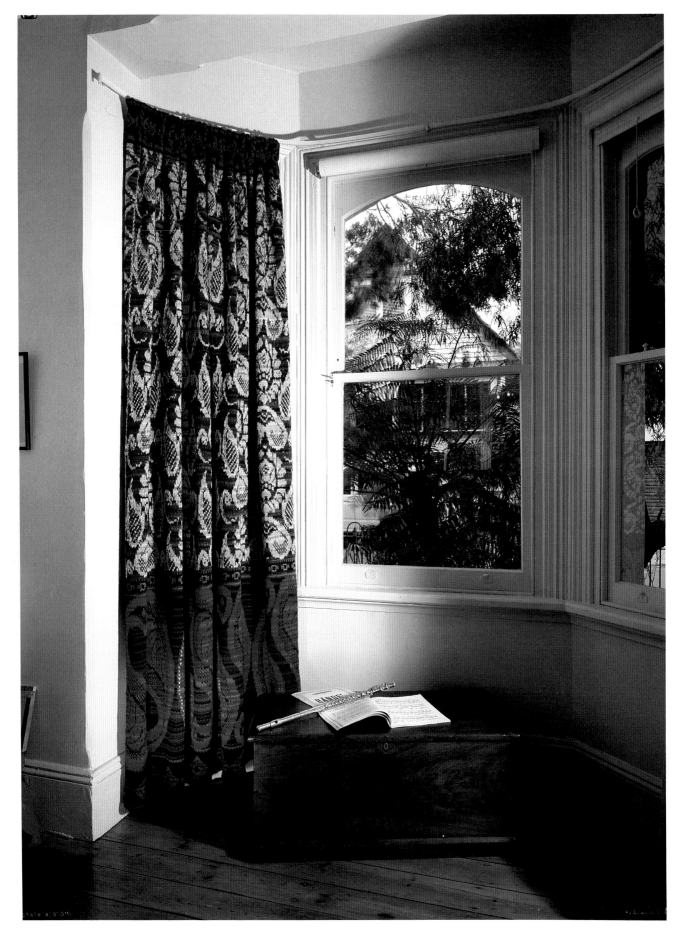

Skazka

Knitted by Denise Gemmell

I found these patterns in an illustrated book of Russian fairy tales. Their bold, ornate design and rich use of colour was instantly captivating. Hence the name 'Skazka' meaning 'fairy tale' in Russian, was so apt for the piece.

The idea of a knitted *'portiere'* or curtain may seem radical. 'Won't it stretch?' I was repeatedly asked. Yes, it will stretch, but it won't keep stretching. Once stretched you have your final fabric. In the instructions, there is a method to assess the stretch. Knitted fabric makes a sumptuous curtain — it's soft, it drapes wonderfully and, when knitted from garment wools, it has the bonus of being a good insulator. Just the thing to hang across a draughty doorway.

Even though I've given you the colour plan, your interpretation of all the shades will make your work unique — an heirloom piece. You will need to know the height of your door or window in order to assess the amount of drop in your fabric. Use an opaque lining, for example the acrylic backed kind, when hanging your curtain against a window, otherwise the light coming through the stitches will detract from the colour pattern.

MEASUREMENTS

Final length after stretching 200 cm x 280 cm.

MATERIALS

Quantities are approximate.
12 ply wool, 50 g balls:
15 balls navy
19 balls blues: royal, mid, etc.
6 balls black
6 balls greens: emerald, turquoise, jade, green blues, etc.
11 balls reds: scarlet, cerise, deep pinks, maroon, etc.
4 balls violets
3 balls slate: indigo, charcoal
7 balls golds: yellows, lemons, biscuit, etc.
8 ply wool, 50 g balls:

12 balls golds: olive, honey, light tans, etc.
5 ply wool, 50 g balls:
6 balls golds: greeny gold, light olive, etc.
1 x 4.00 mm circular needle, 80 cm long.
x 6.00 mm circular needles, 80 cm long
2.25 metres curtain tape, 7.5 cm wide approx.
Curtain hooks, rings as necessary.
Curtain lining to fit.
Matching sewing thread, sewing needle.

TENSION

17 sts. to 10 cm over pattern

COLOUR

Diamond Patterns 1 and 2, small pattern:

Background: consists of navies, black and slate with an occasional row of violet.
Motif — greens: jade, green/blues, etc.

Paisley:

Background — made up of violet, navies, slate and black with violet predominating.
Motif — all the shades of red and maroon through to deep pink.
Contrast stitches — these are x on the chart. Use short, manageable lengths of golds and greens. Tie in extra yarn as needed. Not every motif needs the contrast, in which case work the contrast stitch in motif colour. The contrast yarn is not carried across the row, but simply carried up to the marked stitch.

Flowers:

Background — worked in all the blues, navies and black. Do not use violet or slate.
Motif — all the golds. I also used 8 and 5 ply wools together as I couldn't find enough variety of gold colours in the thicker wools. As I had about 4 different colours in both the 8 and 5 ply, many variations of gold shades were possible.
Contrast stitches — use short manageable lengths. Tie in extra yarn as needed. Use the

Opposite page:
Skazka will certainly become an heirloom. The rich variety of colours gives the appearance of velvet brocade.

113

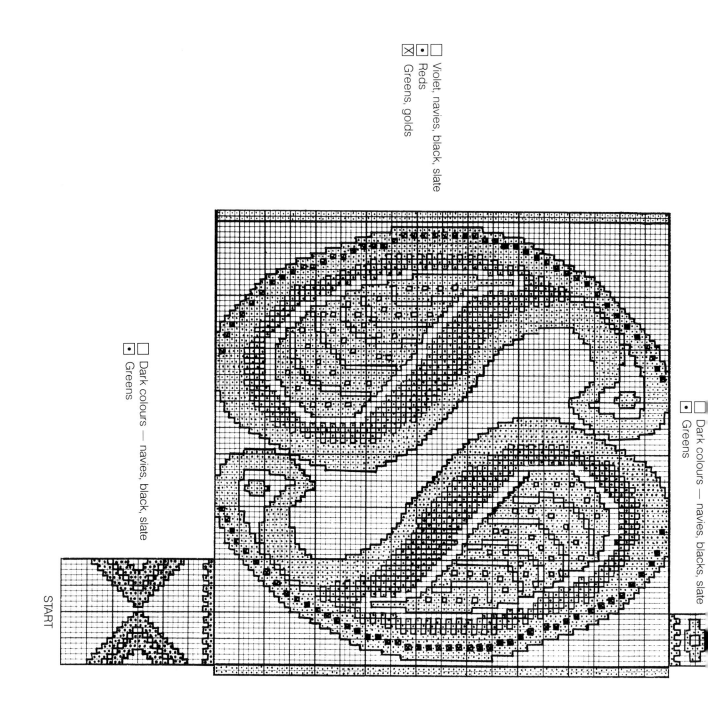

START

☐ Dark colours — navies, black, slate
• Greens

☐ Violet, navies, black, slate
• Reds
☒ Greens, golds

☐ Dark colours — navies, blacks, slate
• Greens

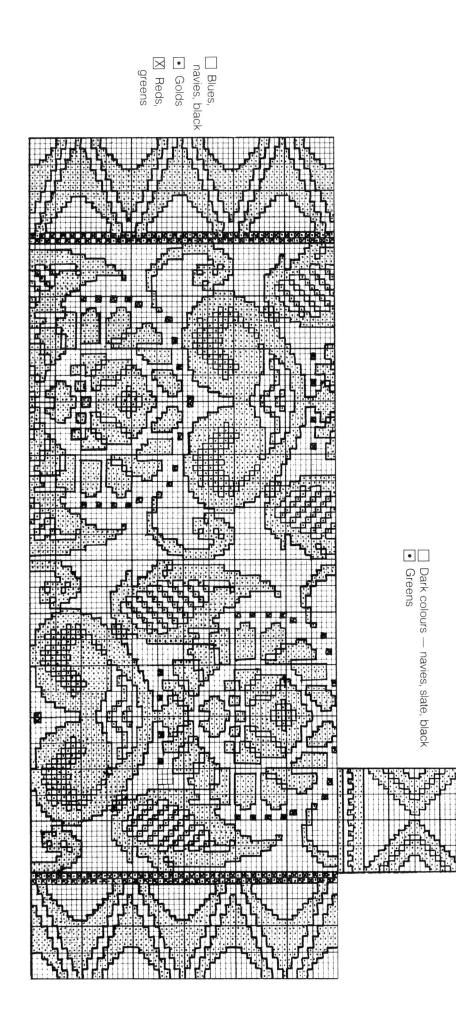

□ Blues,
navies, black
• Golds
☒ Reds,
greens

□ Dark colours — navies, slate, black
• Greens

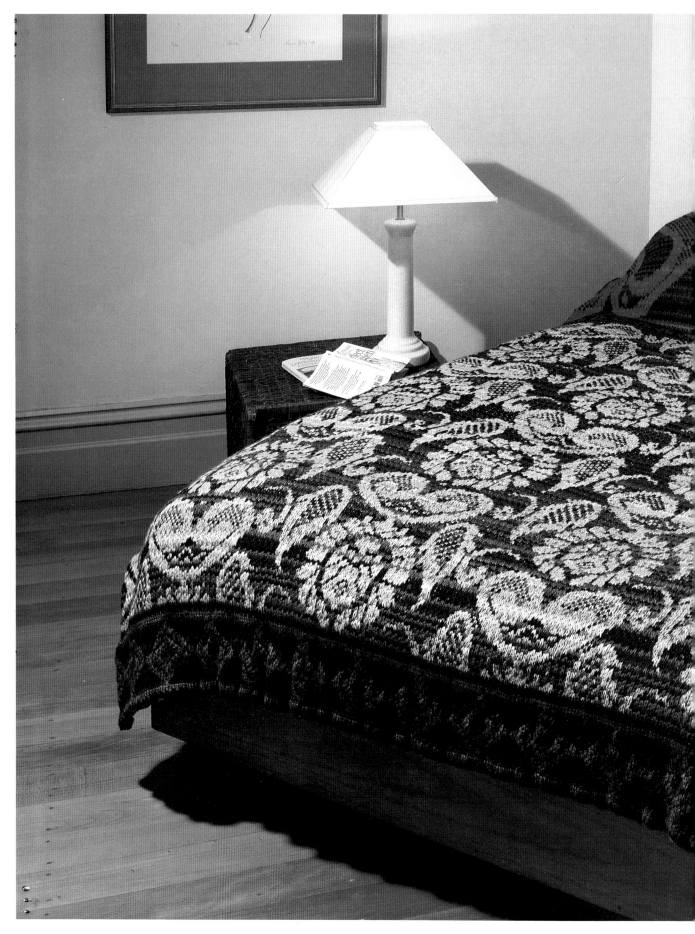

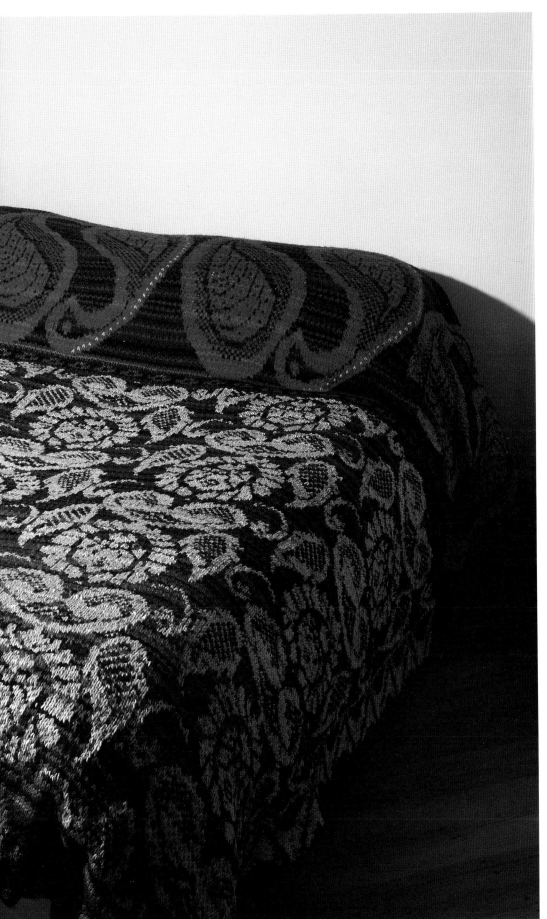

Skazka can also be used as a bedspread. You could omit the side hems and make a deep fringe.

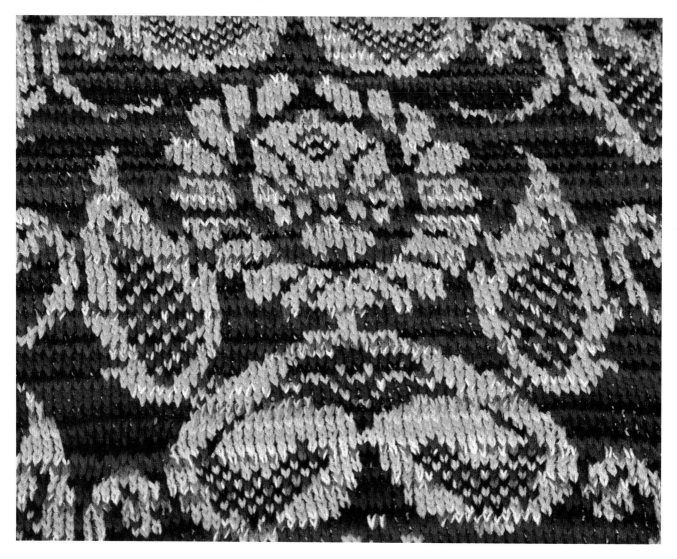

reds and greens. Not every flower need have the contrast, in which case work this stitch in motif colour.

Notes:

1. All of the curtain, except the single colour hems, is worked in K. stitch. Both colours are changed every row to 2 new shades. Using a reef knot, tie new colours to the 2 colours of the previous row. At the end of every row, give both yarns a gentle tug to even up the tension. All the knots will finally be tucked into the side hems and sewn down, so there is no need to make the tails longer than necessary.
2. Weave in the strands at the back of work at every stitch. This is made easier as each row is worked in knit stitch. The woven Fair Isle technique raises and lowers stitches and so creates a varied texture. Because the tension is looser than used on floor pieces, the stranded thread will show its colour through to the right side, again adding to the texture.

The Curtain

With a 4.00 mm circular needle and navy, cast on 320 sts. Work in rows of K. and P. making st.st. for 9 rows.
Next row, K. to form turning ridge of hem. Change to 6.00 mm circular needle and work from graph and at the same time inc. 20 sts. evenly along first row thus: K.8, inc. in next st., *K.15, inc. in next st.: rep. from * to last 7 sts., K.7 — 340 sts.
Beg. working in K. rows only, cutting and tying both colours at each end of every row. After 9 rows from turning ridge, cast on 6 sts. at each end of next row. These 6 sts. are the side hems. Work the 6 sts. in 1 st. of each colour. Alternate the placement of the 2 colours so a dot pattern forms.
Cont. working from chart, maintaining the 6 sts. as side hems.

Motif Arrangement:

Diamond 1 and 2 has its 20 sts. rep. 17 times.
Paisley has its 84 sts. rep. 4 times with 2 sts.

at beg. and end.

Small Patt. has its 10 sts. rep. 34 times.
Flowers have an 18 st. border with a 2 st. line of contrast colour at beg. and end of flowers. The 120 sts. are repeated 2½ times — 2 complete repeats of 120 sts. and then the first 60 sts. once.

ASSESSING STRETCH

After 2 bands of flowers — 120 rows, have been worked, place all sts. on to 3 needles. Secure all knots.
Slip stitch bottom hem, tucking knots inside. Thoroughly wet work and stretch to its maximum length. If necessary, place weights along hem. Ensure work is straight. Allow to dry.
Measure work and compare with your dimensions.
Measure length of one flower and length of diamond pattern and this will let you work out how much more you need to knit.
Resume work and knit to required length.
After 21 rows of Diamond 2 patt., cast off 6 sts. at beg. and end of next row — end of side hems.
On last row of graph, dec. thus: K.7, K.2 tog., *K.15, K.2 tog.: rep. from * to last 8 sts., K.8 — 320 sts.

Change to 4.00 mm circular needle and work turning ridge in P.
Work in rows of K. and P. to form st.st. for 9 rows. Cast off loosely.

HEMS

Slip stitch hem at top.
Tuck knots under side hems and slip stitch into place.

BLOCKING

Thoroughly wet work, stretch to maximum length. Allow to dry.

TO FINISH

Using sewing thread and needles, sew tape to curtain below the hem. Sew lining on to tape and catch lining to sides with a few stitches at intervals.
Gather cords to required width.
Insert hooks.

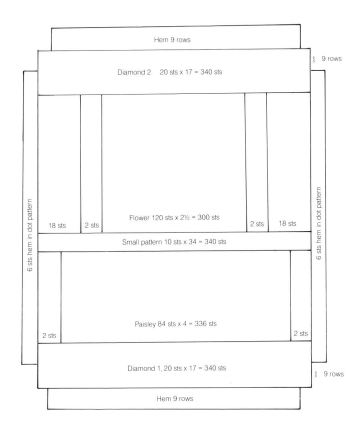

Suppliers

Artmat Pty Ltd
P.O. Box 370
Hawthorn Vic 3122
Telephone (03) 819 2133
Fax (03) 819 5812

Artmat stocks a thick pure wool yarn called
Brolga Craft Wool which is available in a
large range of colours. It is also available
from various craft outlets. Contact Artmat for
further information.

Woolshed Yarns Pty Ltd
P.O. Box 245
Broadford Vic 3658
Telephone (057) 84 3013

Woolshed Yarns stocks a thick pure wool
yarn called Rya Rug Yarn but only in a limited
colour range. They also sell a range of 8 and
12 ply pure wool yarns in a range of colours.
Contact them for further information.

Bendigo Woollen Mills
Lansell Street
Bendigo Vic 3550
Telephone (054) 42 4600
Fax (054) 42 2918

Bendigo Woollen Mills carries a large range
of 5, 8 and 12 ply pure wool yarns. Contact
them for further information.

Champion Textiles
16 O'Connell Street
Newtown NSW 2042
Telephone (02) 519 6677

Champion Textiles carries a large range of
yarns in wool and blends in various plies.
They also carry Brolga Craft Wool. Contact
them for further information.

Hycraft Carpets Pty Ltd
Wool Shop
11-27 Harris Road
Five Dock NSW 2046
Telephone (02) 713 1777

The Hycraft Wool Shop has a com-
prehensive range of rug yarns in wool and
blends. Most of my rugs were knitted with
yarns from Hycraft. Contact the Wool Shop
for further information.

*Please note: All of the above accept mail
orders.*